A STEP-BY-STEP GUIDE TO
BOTANICAL
Drawing & Painting

Create Realistic Pencil and Watercolor Illustrations
of Flowers, Fruits, Plants and More!

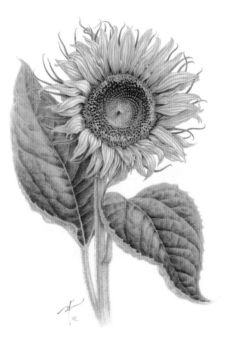

HIDENARI KOBAYASHI

TUTTLE Publishing

Tokyo | Rutland, Vermont | Singapore

CONTENTS

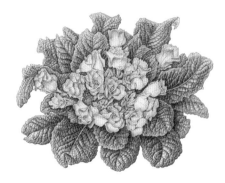

Why I Wrote This Book

Do you need to have a green thumb to be a good botanical artist? Luckily the answer is no; but it just might help! I imagine that if you're interested in botanical art, you're more than just an artist, you're also a lover of plants. They offer so many shapes to replicate, so many beautiful, natural forms. I came to botanical art through my love of flora, their shimmering surfaces and varied textures, the color and structure of an intricate bloom. Thirty years later, I'm still hooked on the habit and glad to be sharing what I've learned with you now.

Botanical artists are drawn from many walks of life. The great Japanese botanist Tomitaro Makino was also a master of botanical painting. He continued to tirelessly draw plants while also studying and researching them. When you look at the huge amount of paintings he left behind, you can sense not only the deep respect, but the deep understanding and insight that informs his work.

Drawing isn't easy, creating realistic and accurately appealing likenesses of these often intricately organic forms is a challenge as much as a reward. Just remember that many specimens sprout along the path. Choose the ones you find the most appealing, the flora forming on the page are sprouted in your interests and imagination. I hope that this book will help guide you along the way and that you'll be able to create botanical art unique to you.

The planning, photography, editing and design of this book could not have been possible without Katsura Yoshimura of NIHONBUNGEISHA, the photographer Norihito Amano, Kazue Sudō of Viewkikaku, designer Naoko Kuge and book designer Amane Kiribayashi. I'd like to express my deep gratitude to all of them for creating this wonderful work.

I'd also like to convey my sincere gratitude to my wife, Keiko (who complimented my first drawing of a dahlia in the summer of 1988 and has encouraged me ever since) as well as to everyone in my classes who have nurtured and inspired me.

—Hidenari Kobayashi

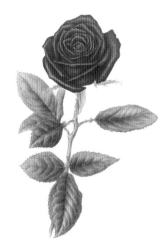

Hydrangea

Hydrangea macrophylla f. *normalis* Hydrangeaceae
A clockwise arrangement shows the annual changes the
plant undergoes. This work was exhibited at the Kew
Botanical Gardens Flora Japonica Exhibition.

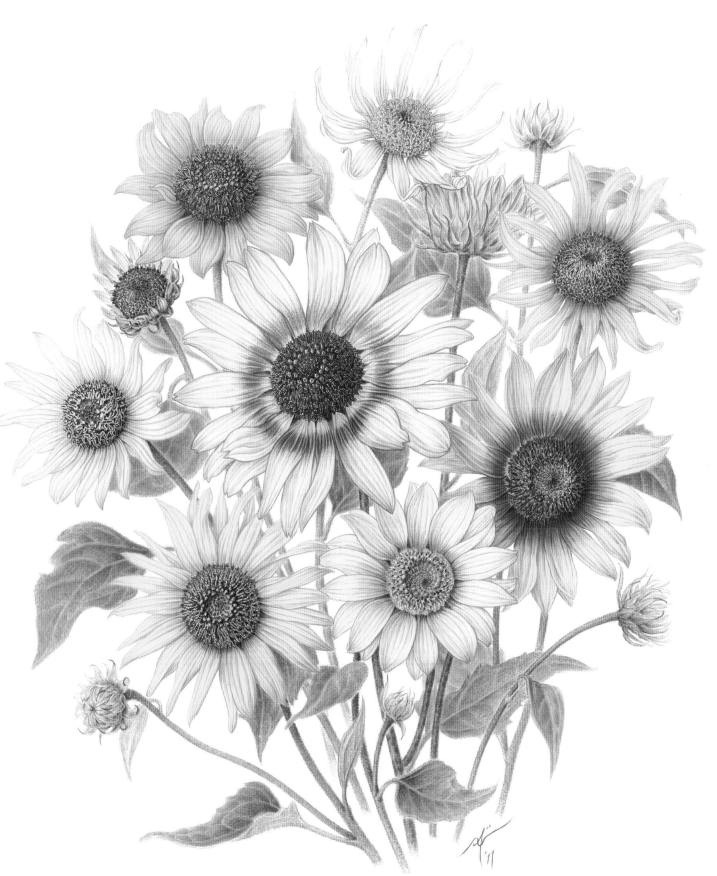

Dune Sunflower
Helianthus cucumerifolius Asteraceae
A bouquet-style composition with sunflowers
in various stages of bloom.

Formosa Lily
Lilium formosanum Liliaceae
As its name suggests, this specimen hails
from Taiwan. The elegant trumpet-like
blooms of the lily have drawn botanical
artists for ages.

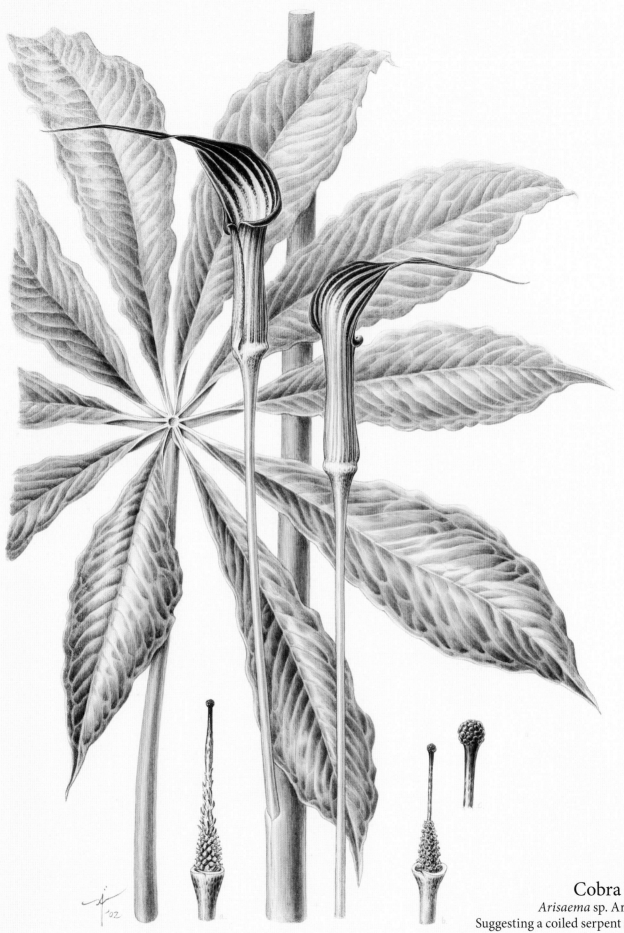

Cobra Lily
Arisaema sp. Araceae
Suggesting a coiled serpent about
to strike, this unique species has rounded,
dark purple tips on the appendages.

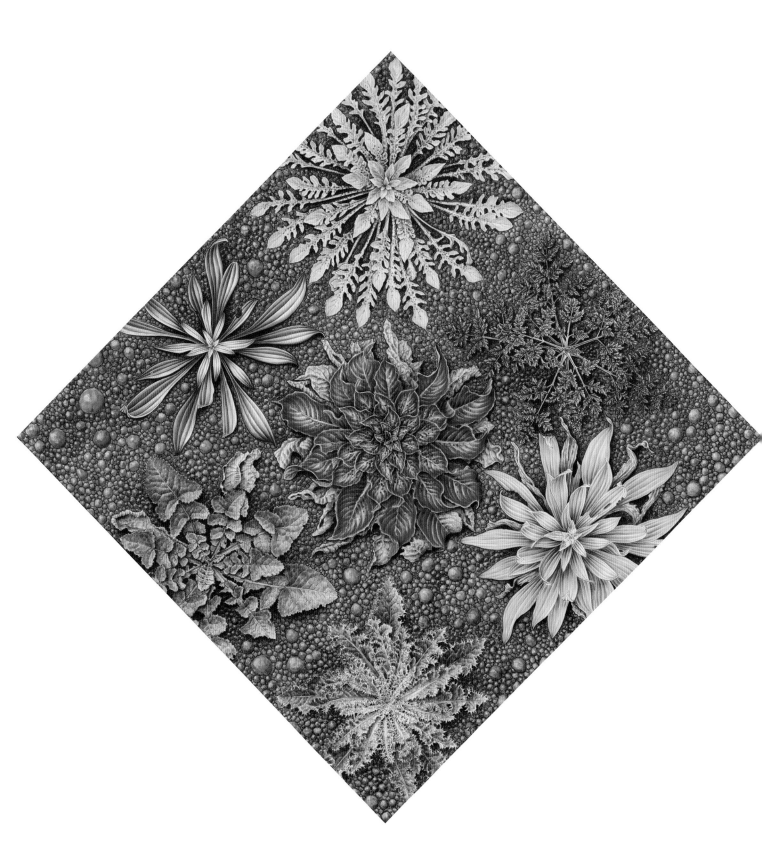

A Rosette Mandala
Clockwise from the top are cutleaf evening primrose, purple keman, ribwort plantain, spiny sowthistle, common sowthistle and ribwort plantain; a common evening primrose adds its ruddy hues to the center.

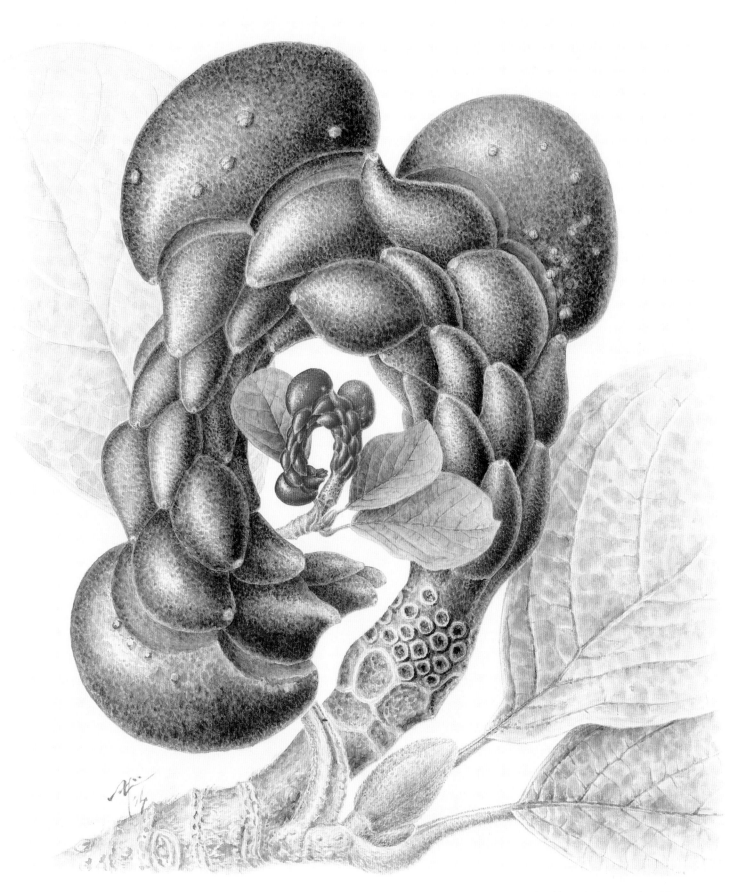

Yulan Magnolia Fruit
Magnolia denudate Magnoliaceae
The enlarged view of the fruit has been given a
monochromatic gray wash, while the life-sized,
to-scale version of the tree's fruit has been colorized.

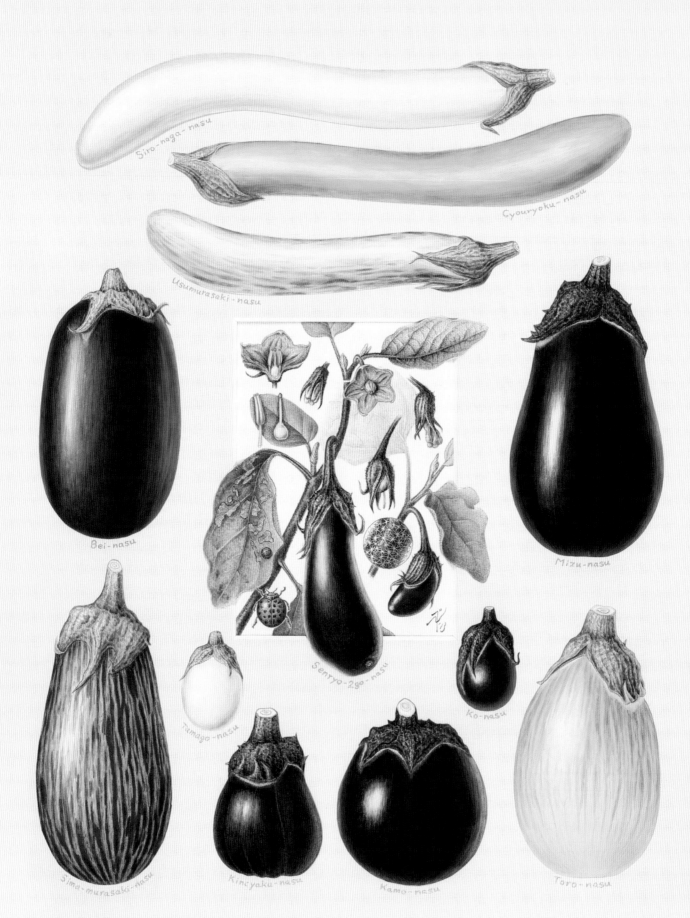

Twelve Types of Eggplant
Solanum melongena Solanaceae
Unique varieties and species encircle an old-fashioned
botanical illustration.

The Enjoyment of Drawing Plants

Accurately and beautifully capturing plants is an evolving process and an ongoing challenge. How precisely did this art form come about? What's the history of botanical art? What does the beginning botanical artist need to know about plants? In this section, we'll take a closer look at some of these key topics and concerns.

Caesar's Mushroom

Amanita caesareoides Amanitaceae

Caesar's Mushroom is a spike of color contrasting with its woodland habitat. Mushrooms aren't plants exactly, but with their variety of surfaces and features, they're an ideal choice for a botanical illustration.

The Attractions of Botanical Art: A World of Many Pleasures

Perhaps the best part of botanical art derives from the joys of drawing itself. Plants seem to have a mysterious charm, and you're drawn to them as an artistic subject for a reason. There are many people in my classes who have picked up a brush for the first time in decades, draw a plant or flower and become so enchanted with it that twenty years later, they're still at it. As you continue drawing, you'll get in-depth knowledge of the plants and their fascinating worlds. Plants have a much longer history than animals and a greater biodiversity, so by scrutinizing them so closely, you'll come to understand them better.

Learning the characteristics of the plants you're drawing will make you a better artist. So will examining other works of botanical art. Looking

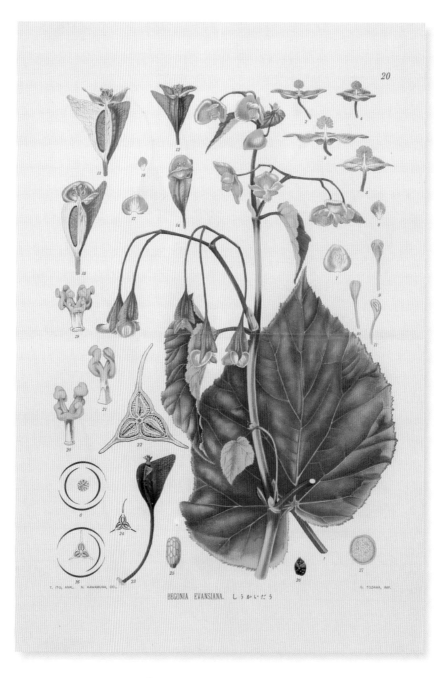

Hardy Begonia Begoniaceae
Artist: Tokutarō Itō
From *Dainippon Shokubutsu-Zui (Japan Botanical Encyclopedia,* 1913) Due to the inclusion of specific parts drawn from different perspectives, you get a deeper understanding of this plant's structure and characteristics.

closely at works from the past and present is essential. A quick glance at the Hardy Begonia on the preceding page reveals the possibilities and particularites of botanical art.

By drawing the plant in its actual growing conditions, the illustration becomes a record for future generations and a window into the past. A large number of horticultural plants were recorded and illustrated during the Edo period (1603–1868) in Japan. These botanical drawings are now a valuable cultural heritage, an aesthetic and scientific resource with social and economic implications. Sometimes an artwork is more than just an artwork.

Finally, botanical art allows you to connect with others around the world. Through social media and the developments of the digital age, the popularity of botanical art continues to spread. It's another window onto our world, as seen through its brilliant and beautiful biodiversity!

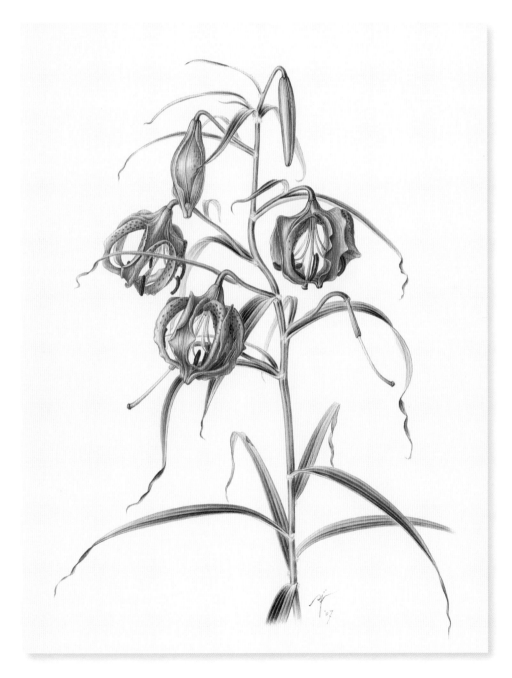

Leichtlin's Lily (lantern-like bloom)
Lilium leichtlinii Liliaceae. Here, an individual stem includes flowers in various stages of bloom, offering a range of botanical references.

The History and Characteristics of Botanical Art

From Research to Appreciation

Botanical paintings have existed since ancient times and through the years have benefited from advances in botanical research, especially when it comes to medicine and horticulture. The father of modern botanical art is Pierre-Joseph Redouté, who was active in the early nineteenth century. His early efforts led to the publication of increasingly detailed and beautifully illustrated botanical reference works. The world of artistic botanical paintings was born, giving rise to generations of talented artist-scientists.

Before World War II, botanical paintings were referred to as illustrations and drawn exclusively for research purposes. It was after the war that the term "botanical art" began appearing. This led to a shift to a more free-form style of botanical paintings appreciated for their aesthetic appeal and created for that sake. Still, the scientific aspect of botanical art hasn't been forgotten or ignored. Whether seen as a scientific specimen or an inspired creation of nature, plants and flowers offer the artist an array of approaches.

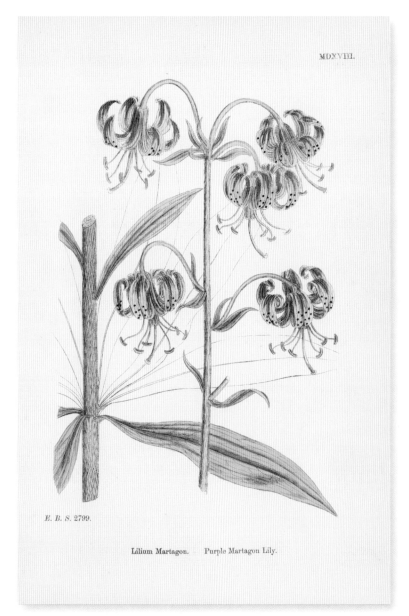

E. B. S. 2799.

Lilium Martagon. Purple Martagon Lily.

The Difference Between "Specimen Paintings" and "Ecology Paintings"

Botanical art can be roughly divided into two broad areas of focus: specimen paintings and ecology paintings. The former centers on just the plant and doesn't include the backgrounds, vases or other related items found in ecology-style renderings. It's typical to depict only one type of plant drawn life-sized from a scientific perspective. Partial drawings (cross-sections, enlargements and other anatomical elements) may be included in the margins to highlight more of the plant's particular characteristics.

Martagon Lily
Artist: James Sowerby
From *English Botany* (1883)
The stem with whorled leaves, characteristic of this lily, and a flowering stem have been cut and placed side by side, a staging or placement that's unique to specimen painting.

Some renderings focus on the plants in their natural settings or habitats, and the entire environment where the plants thrive is included (see Caesar's Mushroom on page 11). Not only are other species typically shown, but insects appear, crawling along the stems and leaves and adding to the sense of realism.

Many artists embrace the freedom botanical art provides: instead of drawing only life-sized works, enlarged flowers and fruit are created as well as free-form works, including blooms gathered in a bouquet.

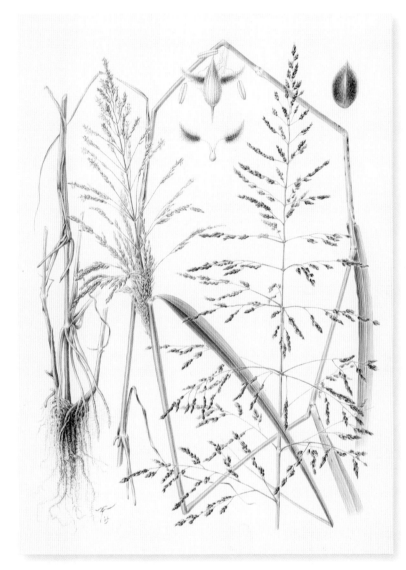

Johnson Grass

Sorghum halepense Poaceae
The stems are bent in order to fit them into the picture. These are specimen drawings: enlargements of the flowers and seeds have been included near the top.

Gaining More Understanding of Botanical Art

Here are some books for those who want to learn more about botanical art.

Botanical Art No Sekai: Shokubutsu-Ga No Tanoshimi
(*The World of Botanical Art: Enjoying Botanical Painting*)
Asahi Shimbun, 1987

It's been more than thirty years since this book was first published, yet I don't think there's any other resource that can convey the attraction of botanical art as concisely as this one. Unfortunately, it's out of print, but it is available as a used book on sites like Amazon and worth searching out.

Zusetsu Botanical Art (*Illustrated Botanical Art*) by Hideaki Ohba, Kawade Shobo Shinsha, 2010

This beautifuly illustrated work has the perfect content for learning about the history of botanical art. The author, Hideaki Ohba, is a botanist with a deep knowledge of botanical art, and he contributed the commentaries on the three illustrated volumes published by the Japanese Association of Botanical Illustration (see page 127).

The Process of Creating Botanical Art

Preparing Yourself and Getting Started

Whatever the case, try drawing one line

It all starts with a line, then another. A plant starts to take shape before your eyes.

Start by completing your first illustration

No matter how small, produce a simple botanical illustration and experience the joy of creating your own original artwork!

Keep drawing and producing new work

The more you draw, the better you'll become. Practice leads to mastery. Start studying techniques and referring to books like this one.

Creating an Environment for Drawing

① Supplies & Preparation

First, prepare the plant you want to draw along with the paper, paints, brushes, pencils and any other art materials needed.

※ See page 18 for information on art materials.

② A Place to Draw

Be sure you have a place where you can easily work when you want to draw. A desk space of around 28 square inches (70 square cm) is fine.

③ A Time to Draw

Set yourself a regular time to draw. Focus on drawing, whether it's once a day, once every three days or once a week.

The Process Used in This Book

There's more than one way of drawing a picture. There are no set rules to follow, but a few common steps do help every time. The works featured in this book were created using the following process:

LINE DRAWING (SKETCH)

Draw the outlines of the plants, including the leaf veins, hairs and other details to create a sketch.

ADDING COLOR

OUTLINE Color the outlines using a color that is close to the base color of the motifs.

SHADING Add shading to the sketch. This part of the process focuses on making the two-dimensional picture suggest a three-dimensional plant.

BASE COLOR Now it's time to add more color and layering effects using the plant's base color. Adding the base color gives the subject a more natural, realistic form.

Getting Ready to Draw Plants

Botanical art is typically created by applying transparent watercolor paints to watercolor paper. So that's all you need to get started. Here, we'll look at the materials you'll need, how to use the brushes and we'll also go over some basic watercolor techniques.

Madonna Lily
Lilium candidum Liliaceae
Also known as the white lily, this symbol of Vatican City is deeply associated with Catholic iconography.

Botanical Art Materials

Drawing botanical art doesn't require special materials. As long as you have some transparent watercolor paints and paper, a palette, brushes, as well as a pencil and eraser for the sketching, you can get started. Here are some easily available art materials you'll need.

Transparent Watercolor Paints

A variety of watercolors are available, but I use Holbein transparent watercolors as they're easy to obtain. I buy each color as needed. Here are the 15 colors used in this book.

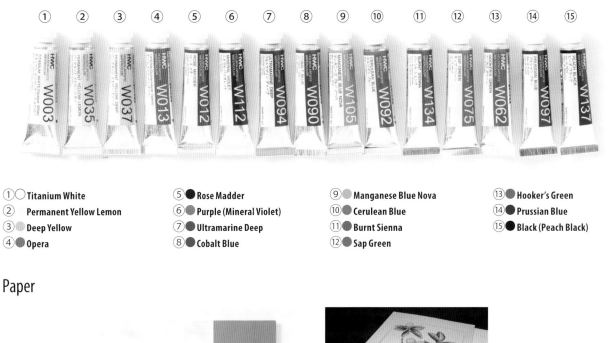

① Titanium White
② Permanent Yellow Lemon
③ Deep Yellow
④ Opera
⑤ Rose Madder
⑥ Purple (Mineral Violet)
⑦ Ultramarine Deep
⑧ Cobalt Blue
⑨ Manganese Blue Nova
⑩ Cerulean Blue
⑪ Burnt Sienna
⑫ Sap Green
⑬ Hooker's Green
⑭ Prussian Blue
⑮ Black (Peach Black)

Paper

Among the various types of watercolor paper, I use Maruman vif Art (F6 fine grain). It's easy to apply the paint and also suitable for doing the detailed drawings that are often required as part of botanical art. The sketchbooks come in two variations: a spiral type where you can turn the page to use the other side, and a block type, shown in the images, where the paper is glued on all four sides.

The advantage with the block sketchbook is that the paper doesn't warp or wrinkle even when color is added. Once you've finished drawing, there's a small unglued opening on the side where you can insert a paper knife or similar tool and use it to cut and separate the four sides. If you use a craft knife, be careful not to damage the paper.

Palette

These come in a variety of materials, including metal and ceramic, but I recommend plastic as it's light and easy to use.

Put the paints on the palette before you begin. When getting paint out of the tube, squeeze as evenly as possible from the back end toward the front. Here, the four blue colors (⑦–⑩) are arranged right to left in order of brightness, and the five colors on the right (⑪–⑮) are the ones often used for leaves.

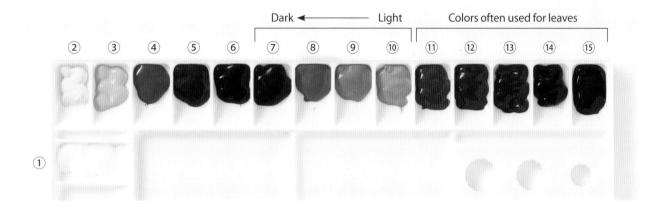

Brushes

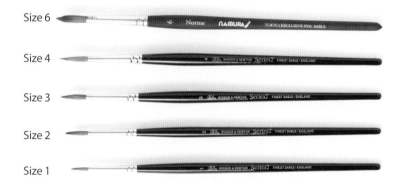

Size 6
Size 4
Size 3
Size 2
Size 1

The thickness of a brush is indicated by the size number. The higher the number, the larger it will be. The Namura size 6 and the Winsor & Newton sizes 1 to 5 round brushes are the ones I use, depending on the surface to be painted. To begin with, a brush between sizes 1 and 3 is fine.

Brush Tub

This is for washing brushes and diluting paints, and it's useful to have one with several partitions. You can also recycle small glass jars or any stable, waterproof container.

Sketching Utensils

Gel Pens

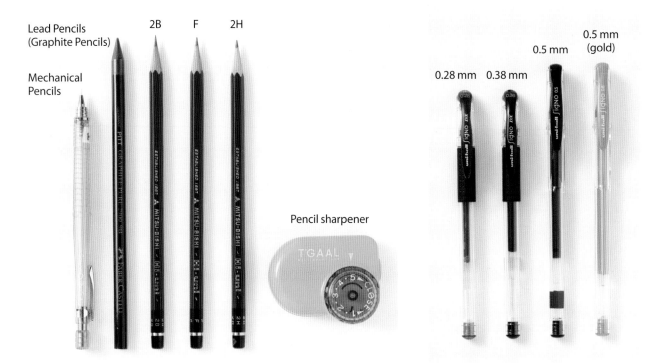

Sketching is done with a pencil. Have pencils ranging from 2H to 2B in darkness ready and use them as needed. It's also fine to use a mechanical pencil (2H) to draw in the details. When tracing (see page 50), I use a 4B pencil or a graphite pencil. The pencil sharpener shown here lets you change the angle at which the graphite is sharpened, so it can be used with different types of pencils; but it's also fine to use a regular pencil sharpener.

These are used when adding penstrokes to sketches. They make the outlines in the sketch clearer than those drawn using a pencil, so even with just a small amount of paint, it creates a well-defined work. The gold pen is used for tracing (see page 51).

Erasing Tools

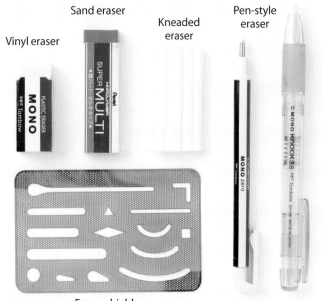

When correcting a sketch, use a vinyl or pen-style eraser, and then before coloring the completed sketch, make the lines fainter by using a kneaded eraser (see page 45). If the paint happens to go outside the lines, it can be corrected by diluting it with water. If that doesn't work, use a sand eraser and an eraser shield (see page 31).

Colored Pencils

Colored pencils are used to add shading to a sketch before starting to add color with paints. Even if shading isn't added with paint, it will create a finish that gives the colors greater depth. The pencils are water-resistant, so they have the added advantage that the colors won't smudge even when paint is applied on top of them.

Tissue Paper

This is used to absorb excess water on the brush and to adjust the amount of paint. A paper towel or an old soft cloth or rag is also fine to use.

Other Tools

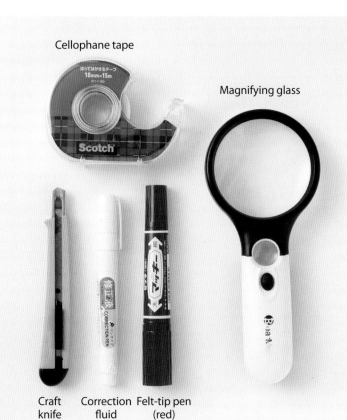

Cellophane tape

Magnifying glass

Craft knife Correction fluid Felt-tip pen (red)

Cellophane tape and felt-tip pens are used when thinking about and developing the composition. It's also useful to have tracing paper on hand (see page 116). Use a magnifying glass to observe the finer details of plants.

When layering colors, it's best to wait until they've naturally dried, but in a pinch a hairdryer can always be used.

Using a Pencil for Line Drawings and Sketches

Line drawings are the most important and fundamental part of creating botanical art. The form of the plant is the deciding factor in classifying it, so draw it as clearly and accurately as possible. If you can capture it effectively at this stage, it'll make adding shading and color much easier later on.

※ Please see pages 36–43 for plant terminology.

How and When to Use Line Drawings

① Using 2B or similar, draw faint lines for the midrib, outline and rough shape.
② Use HB, F or 2H for the final lines to make them bolder.
It's good to make these final lines clear and defined. Keep in mind the following 3 points.

Make the lines clearly visible, NOT vague.

Draw continuous lines, NOT ones that break off partway.

Use single lines, NOT double or triple ones.

※ If there are hairs evident on the leaf surface, draw them as dots, not lines. See the Kalanchoe (Panda Plant) on page 101 for reference.

The Process for Line Drawing

Symmetrical
Core line
Outline

1 Observe the outline and locate the core line that runs through the center. By being aware of the core line while you're drawing, you'll be able to accurately express a realistic and lively plant. The core line can be located in the following ways:
- For stems, it runs from the root to the top of the stem.
- For leaves, it's from the stem through the petiole, along the midrib, to the tip of the leaf (Leaf 1, Leaf 2).
- For flowers, it runs from the stem through the peduncle, the ovary of the pistils and the style through to the tip of the stigma (Flower 1, Flower 2).
- For fruit, it leads from the peduncle through to the style scar at the top.

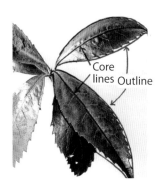

Leaf 1 – Core lines and outlines (Sarcandra glabra)

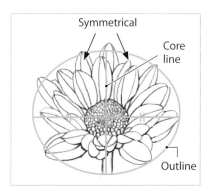

Leaf 2 – Core lines and outlines of a complex lobate leaf (chrysanthemum)

Flower 1 – Find the core lines that run through the center of the plant (common sowthistle)

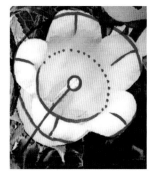

Flower 2 – The core line and outline of a cup-shaped flower (Canterbury bells)

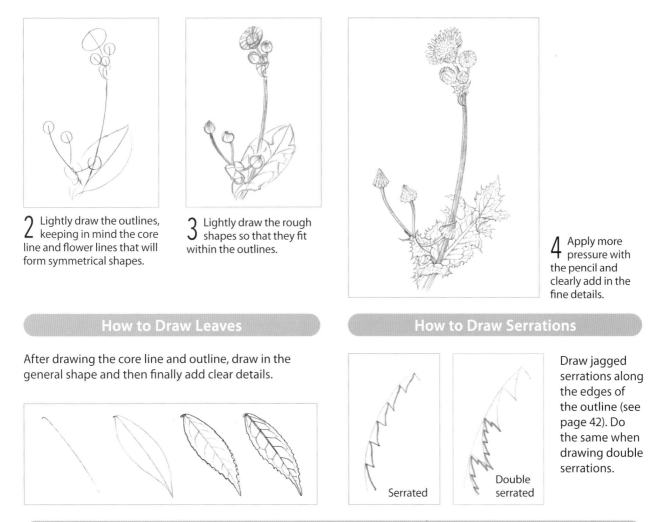

2 Lightly draw the outlines, keeping in mind the core line and flower lines that will form symmetrical shapes.

3 Lightly draw the rough shapes so that they fit within the outlines.

4 Apply more pressure with the pencil and clearly add in the fine details.

How to Draw Leaves

After drawing the core line and outline, draw in the general shape and then finally add clear details.

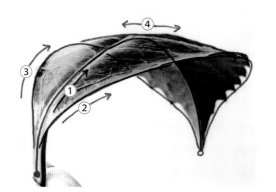

How to Draw Serrations

Draw jagged serrations along the edges of the outline (see page 42). Do the same when drawing double serrations.

Serrated

Double serrated

How to Draw Leaves When Both Sides Are Visible

As with other scenarios, two-sided leaves can be drawn accurately by using the concept of core lines and outlines. The top and underside should not be drawn separately here. Always draw the core line first, followed by the outline in the foreground and then the outline in the background.

First, draw the core line ① from the base of the leaf to the tip. Next, start drawing the front edge line ② from the base of the leaf.

Draw ② to the tip of the leaf and then, again from the base of the leaf, start drawing the back edge line ③.

For ③, join the visible and concealed parts, drawing up to the tip of the leaf, and then draw ④ (the red dots).

For ④, draw it so that it connects lines ①②③ at the points where they curve the most.

On the top side of the leaf, erase the lines that would normally not be seen, then draw in the detailed parts.

Using the core line and outlines as a base, add the lines necessary to complete and fill in the leaf.

Creating a 3D Effect Through Shading

As I explained in the production process outlined on page 16, once the sketch is complete, I add shading to create a three-dimensional appearance. Here I'll introduce the process for creating this effect and adding shading to the leaves. In Part 3, there are examples of shading for a variety of plants, so turn to that section for additional reference.

Shading Using Gradation

Shading is expressed by using gradation that goes from the brightest part (highlight) to the darkest part. If there's only a slight change in gradation, the result will not look very three-dimensional. Works that have a three-dimensional effect often have more exaggerated light and dark gradation contrasts than the actual gradation of the plant.

Gradation in Shading

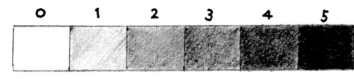

Adjust the degree of gradation by using 0 to 5 when drawing large objects and 0, 1 and 4 when drawing smaller objects.

The Basics of Shading

A plant can be seen as a combination of three solids: a sphere, a cylinder and a cone. Practice shading these three shapes and then use the techniques when drawing. In some cases, it's better to make the shading more exaggerated than it actually is. Rather than aiming to draw the exact shading patterns that are visible only to you, try to create light and dark effects and pairings that will look three-dimensional to others.

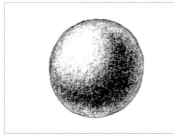

A sphere is created by using shading to form a convex curved surface. This is essential when capturing petals, leaves and fruit.

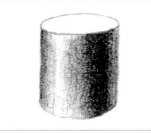

The shading for cylinders is mainly used for branches and stems.

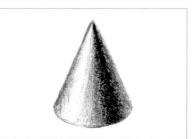

The shading for cones is mainly used for buds, sprouts and fruit.

Combining Types of Shading

Along with simple combinations of shading, like the the first photo on the next page, there are also combinations of partial shading coupled with larger areas of shading, as in photo 2. The shading for leaves is the same (see page 25). Moreover, with flowers, there are times when the shading technique shown in photos 3 and 4 is used. In these cases, the approach is the opposite of those for the sphere and cone.

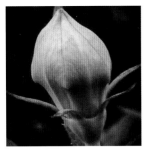

1 A combination of shading for upward- and downward-pointing cones (balloon flower).

2 Layered shading of individual berries and the aggregate fruit (cobra lily).

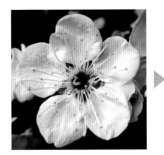

3 Shading for concave petals (plum blossom).

Shallow concave shading (used for a bowl-shaped flower).

4 The petal interiors are dark and there's a difference in the degree of brightness between the left and right (Japanese bindweed).

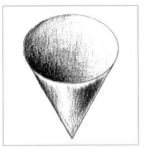

Shading of the cone's interior.

Shading has been added (spray chrysanthemum).

This is the line drawing of a spray chrysanthemum on page 22 with shading added. After this, on page 32, the unique colors will be painted on in layers.

How to Add Shading to Leaves

Leaves, unlike flowers and stems, are almost flat, so it's difficult to see the shading sometimes. It can also be extremely difficult to accurately capture the shading of leaves facing in different or varying directions. To make this task easier, establish a few set rules when it comes to shading. Here I'll use a hydrangea leaf to explain.

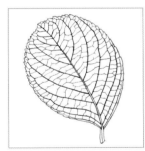

1 The leaf veins are divided into the midrib, leaf margins, lateral veins and sublateral veins (see page 40).

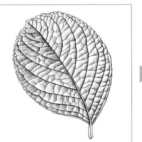

2 Add light shading to the sublateral veins (A).

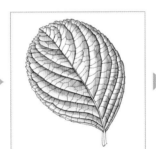

Add more shading between the lateral veins (B).

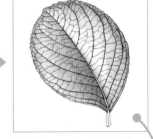

Add deeper shading to the midrib and leaf margins (C).

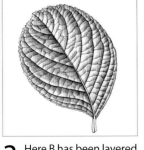

3 Here B has been layered on A.

4 This is the final shading with A, B, and C.

TIP

Add shading by applying dark areas along one side of the veins and then blurring them in the opposite direction (see page 29). The spaces between the veins on the leaf's top side are convex, so when light comes at an angle from the left, the side to the left of the veins will be darker. The shading on the underside will be the reverse of that on the top. Use the veins as borders and alternate the shading pattern: light, dark, light, dark and so on. The shading for leaves with clear sublateral veins (such as hydrangea and primula) is layered in order A→B→C. If step A doesn't show the shading clearly (for example with roses and kumquats), then layer in reverse order: C→B.

Brush Techniques

Brushes are available in many shapes and sizes, but if you have three brushes of different thicknesses, that should suffice for your various needs. Learn what kind of line you can draw with which brush and then use them accordingly to produce a variety of effects.

When Applying Color

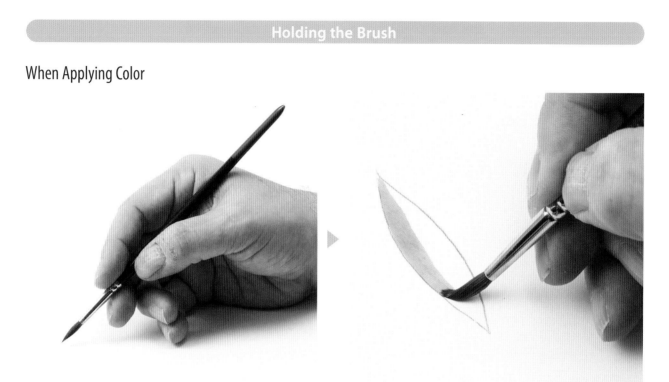

Hold the brush close to the ferrule and place the side of your hand against the paper as support so you can slide and move it in a steady motion.

When Painting Details

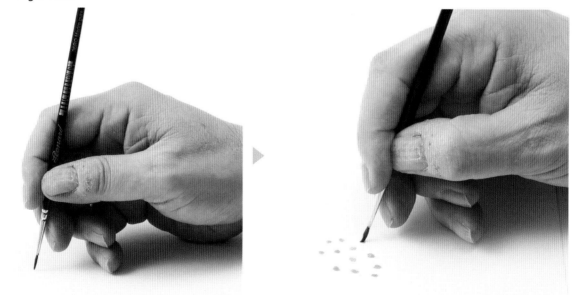

Hold the brush close to the ferrule so that the brush stands upright. If you support your hand with the side of your little finger, you can easily add fine details.

Drawing Lines

Bold Lines

Be sure there's enough paint on the brush and draw using the belly of the brush.

Fine Lines

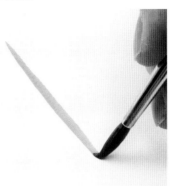

Slightly lift the brush and with light pressure, use the tip to draw.

Even Finer Lines

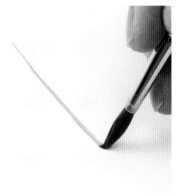

Hold the brush upright and use the very tip of the brush to draw.

Applying Color

Narrow Leaves and Petals

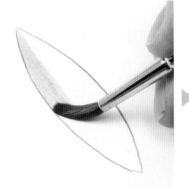

Paint along the outline on one side of the leaf.

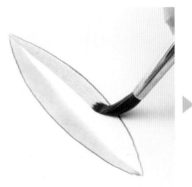

Paint the other side the same way. Hold the brush horizontally and paint so that the color spreads.

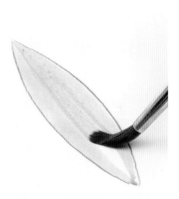

Fill the gap in the center by painting and mixing the color at the same time.

Wide Leaves and Petals

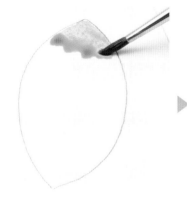

Start painting from the tip of the leaf.

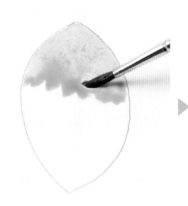

Hold the brush horizontally and paint so that the color spreads.

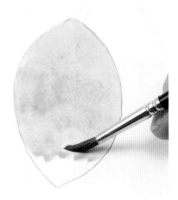

Try not to rough up the paper and spread the paint evenly.

Basic Techniques for Watercolor Painting

On page 26, I introduced how to use the brush. Here I'll explain basic techniques for creating and adding colors using paints, as well as how to correct any mistakes you may make along the way.

Creating Colors

Wet the brush with water.

Use the edge of the brush tub to remove any excess water.

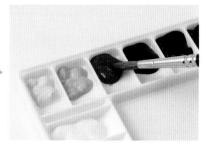

Add a small amount of paint to the tip of the brush.

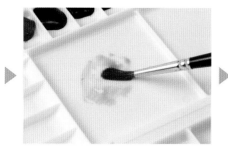

Dilute the paint on the palette.

Wet the brush in water again.

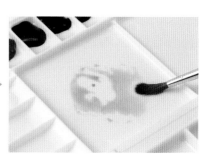

Thin the paint with water until you can see the palette through it.

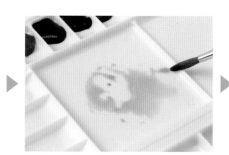

Adjust the amount of paint on the brush using the palette's mixing compartment.

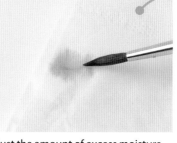

Adjust the amount of excess moisture using tissue paper and then apply the brush to the paper.

A paper towel or an old towel or rag can be used, but tissue paper is best when making fine adjustments.

TIP

Combining Paint Colors

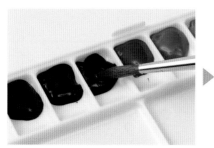

Load Ultramarine Deep on the tip of the brush and prepare to mix it with the previously diluted Opera.

To begin with, dilute the paint in a different compartment on the palette.

Adding Ultramarine Deep to Opera creates purple.

Making a Large Amount of Color

Fold a piece of tissue paper and soak it in water.

Squeeze the water on to the palette.

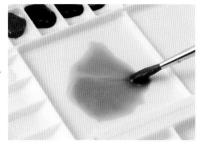

Dilute the paint. Try to create the amount of color that you want to use.

Horizontal Painting and Gradation

Horizontal Painting

Move the brush slowly to apply the paint.

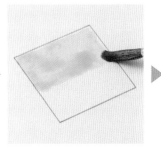

Paint in one direction, from left to right.

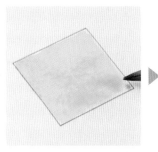

Do it so that the density of the paint is even.

Horizontal painting is a basic technique for adding color.

Blurred Gradations　※ This is used in the practical lessons for Rose on page 66 and Holly on page 90.

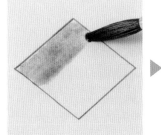

Prepare light and dark colors, and apply the dark color first.

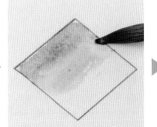

Next, apply the lighter color.

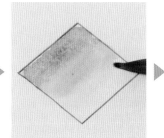

Thin it with more water and apply it again.

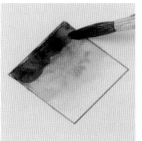

Layer using a darker color than the first one.

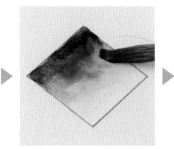

Next, layer using a slightly lighter color.

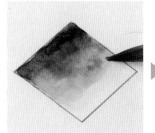

Apply the paint so it mixes and blurs naturally.

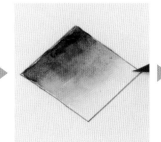

Thin and blur it more using water.

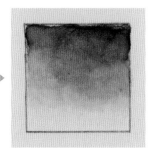

This is used for adding shading to glossy leaves and when painting a lot of plants.

Line Gradations

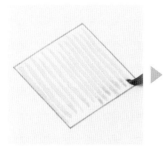

Prepare the light and dark colors, and to begin, draw lines using the light color.

Next, draw lines using the dark color.

When you want the color to become gradually lighter toward the bottom, apply the color only to the top.

Layer using a slightly darker color than the previous one.

Layer more using darker colors.

Layer the lines, adjusting the color density.

Adjust the density even more.

Use this technique when drawing plants that have leaves with parallel venation (see page 40).

Dot Gradations ※ This is used in the practical lesson for the kalanchoe (panda plant) on page 101.

Adjust the amount of paint on the brush using tissue paper. When stippling, it's best to use a brush that doesn't have a lot of moisture.

Prepare the light and dark colors; to begin, taking the light color and using the tip of the brush, create fine dots across the whole surface.

Next, stipple using a darker color. When you want the color to become gradually lighter toward the bottom, add more dots to the top and as you move down, make the ones toward the bottom sparser.

Add dots using a slightly darker color than the previous one.

Layer the darker colors.

Layer with an even darker color.

Layer the dots, adjusting the color density.

This appraoch is used when drawing plants with fine hairs.

Techniques for Fixing Stray Paint

Removing Paint Splashes

 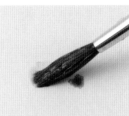 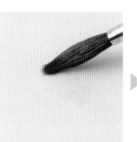

If paint splashes on the paper, remove it immediately by adding water to make it float up.

Use a wet brush to get the paint to float up.

Once the paint has surfaced, squeeze the water out of the brush and then use it to soak up the paint.

The stray mark has been easily and cleanly removed.

Fixing Stray Paint Marks with Water

When paint has bled outside the outline, wait until it's completely dried and then fix it.

Use a wet brush to make the stray paint mark rise to the surface.

Once the paint has surfaced, squeeze the water out of the brush and then use it to soak up the paint.

If you try to fix it while the paint is still wet, the color inside the outline will also bleed, so be careful.

Fixing Stay Paint Marks with a Sand Eraser

If using water doesn't fix the mistake, use a sand eraser.

Position an eraser board on the part where the paint has strayed.

Use a sand eraser to remove it. Be careful not to use too much force.

When you use a sand eraser, it removes some of the paper too.

Place some tissue paper on top and gently rub the area with your fingernail to smooth the surface of the paper.

The stray paint has been neatly removed.

Layering to Create Unique Colors

Once shading has been added to the sketch, making it look three-dimensional, it's time to color and layer the characteristic colors of the plant. By adding color through combined and layered colors, the plants can take on a much more natural form.

Understanding Transparent Watercolor Paints

The three images below show the same shaded spray chrysanthemum from page 25 with different unique layers of color added. As these are transparent watercolors, the previously added shading will remain visible.

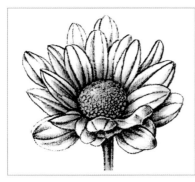
Grays to light blues added

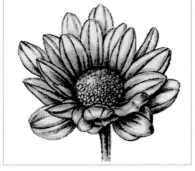
Yellows to oranges added

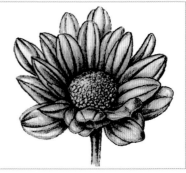
Pinks to reddish purples added

Transparent watercolor paints are available in many colors. The Holbein paints used in this book come in a total of 108 colors. Even if you were to buy all of them, it would be difficult to utilize them all, so to begin with, 15 colors are fine. In regard to the paints you'll use, it's a good idea to try a few test strokes beforehand. You can use the same paper as the artwork for this. Add the swaths of color so they're arranged in the same order as on the palette and so that you can see the difference in tone when each is applied. Create a sample palette for your colored pencils in the same way.

Transparent Watercolor Paints – Color Examples

| TW | PYL | PYD | O | RM | MV | UD | COB | MB | CEB | BS | SG | HG | PB | B |

TW: Titanium White (opaque)
PYL: Permanent Yellow Lemon
PYD: Permanent Deep Yellow
O: Opera

RM: Rose Madder
MV: Mineral Violet
UD: Ultramarine Deep
COB: Cobalt Blue

MB: Manganese Blue Nova
CEB: Cerulean Blue
BS: Burnt Sienna
SG: Sap Green

HG: Hooker's Green
PB: Prussian Blue
B: Peach Black

Colored Pencils – Color Examples

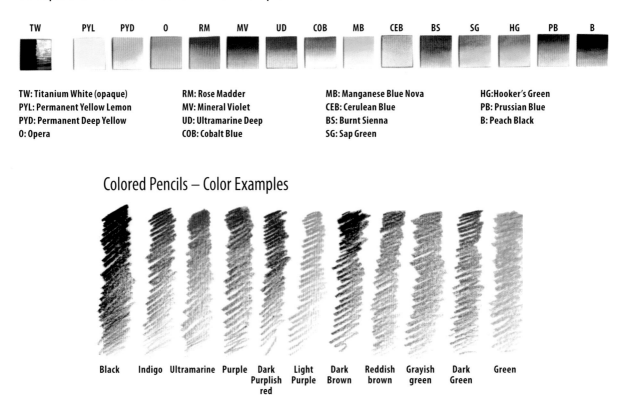

Black · Indigo · Ultramarine · Purple · Dark Purplish red · Light Purple · Dark Brown · Reddish brown · Grayish green · Dark Green · Green

Combined Colors and Layered Colors

With transparent watercolors, you can create a countless range of colors by combining or layering your 15 base paint colors. Layered colors, especially, allow you to create complex hues and tones, but it's best not to use too many. Start simple, by blending just a few, and then go from there.

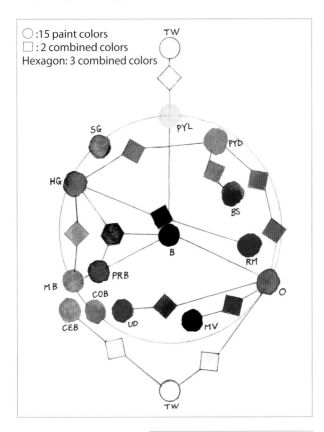

○ :15 paint colors
□ : 2 combined colors
Hexagon: 3 combined colors

Combining Colors Based on a Color Wheel

These examples use 15 colors arranged like a color wheel. Combining two adjacent colors will create a neutral hue, while combining two colors that are opposite each other will create a brownish or black-toned color. While combining colors is a useful technique to master, even if you create a color close to the one you're aiming for, layering might still be the best approach. In the case of transparent watercolors, layering the colors will get you much closer to the desired look and effect and give you a greater sense of control. When colors are combined, it decreases their vividness and the degree of saturation. Judiciously use combined colors for branches and leaves, which are not usually very vibrant. Use layered colors for bright flowers and fruits, where a higher saturation is often what you're after.

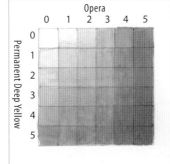

Examples of Layered Colors

This is a example layering two colors (Opera and Permanent Deep Yellow) ranging from light to dark, with five levels of density created using different amounts of water. This shows you that even layering can create a variety of colors with greater depth than combined hues. Mixing the colors beforehand means that you can predict what colors will be produced when they are layered.

Expressing Texture

Differences in texture can be reflected through changes in the brushstrokes. For the hairy or more textured part (the fruit) of the southern magnolia, create dots by adding paint little by little with the tip of the brush. For the smooth part (the seed), make smooth movements with the brush and leave clear highlights throughout.

3 Key Points for Adding Color

- **Add paint to the brush down to the base**
Adjust the amount of paint by stroking the tip of the brush with tissue paper.

- **Apply to the paper in light strokes**
Reduce the amount of downward pressure by gliding the side of the brush head along the paper.

- **Don't paint the same place more than 3 times**
Keep moving to new sections before the previous paint starts to dilute.

Q&A: Botanical Art Issues

Q Are you not allowed to say that a copy is your own work?

A A long time ago, I spotted someone copying a work on exhibit at the Museo Nacional del Prado in Madrid. They were art students who had permission, and while some were just starting out as artists and some had considerable talent, you could feel the seriousness each person was putting into the work. It's not something you see in Japanese museums, so I couldn't help staring. It was a brief moment during my trip, but I remember feeling envious of them being able to spend all day in the quiet museum in front of all these masterpieces.

In Europe and the United States, this way of copying is recognized as part of a painter's training. The purpose is not to make a copy, but to explore the painstaking efforts and ingenuity the original artist undertook to create the work, along with discovering their process. Then you let that become the seed for establishing your own process and your own distinctive style.

In a sense, the original artist acts like a teacher. We learn from her or him through the artwork. From that perspective, copying masterpieces is not a bad way to learn. However, the finished copy is not your own work. It's a reproduction of a work by someone you regard as your teacher. If you try to pass off the work as if it were your own, it will lead to copyright issues and even if you are within the legal boundaries, your morals as an artist will be questioned.

If you want to display your work at an exhibition, show respect to your teachers and mentors and make sure you always give credit and idenitfy the source of your insrpiration, for example, "From Redouté's *Les Roses*, respectfully copied by [name]".

Q Is it fine to use photographs?

A If the photographs you're using to create a work are ones you have taken yourself, this is fine. If you're using photographs taken by other people, just like copying other original sources, credit must be given. It's just good practice and shows how your own illustrations and artworks have eclipsed, transformed or redefined the original.

Vermeer, renowned for masterpieces like *Girl with a Pearl Earring,* is said to have used a camera obscura to create his works. So there is nothing wrong with using photographs or other visual sources to paint. Photographs can capture the shapes and colors of plants instantly. It's also difficult to draw a three-dimensional object on a flat surface, so photographs can make this easier. It's difficult, however, to draw with botanical or scientific accuracy using only photographs. You still need to observe the plant closely to able to see the structure and details.

Q How do you keep the plants fresh?

A First of all, I recommend choosing a motif that doesn't change easily. This includes dried fruit, succulents and cacti, orchids and potted plants.Cut flowers wilt easily, so you need to devise ways to keep them looking fresh. Start by cutting the stems at an angle while they're immersed in water, as this improves their water intake. This is a well-known technique in ikebana, so it's a good idea to check books and information online about this.

Tomitaro Makino is said to have used a glass vivarium, similar to a doll's display case. The container is used to maintain a constant humidity, as the lower the humidity, the more rapidly the plant wilts.

At higher temperatures, a plant deteriorates or wilts more quickly, so lowering the room temperature is another effective approach. When doing that, it's best to turn the plant upside down and spray water on the underside of the leaves.

Basic Lessons in Botanical Art

Careful observation followed by drawing a life-sized pencil sketch are the key first steps. Then add color with transparent watercolor paints and you're done. Easy, right? In this section, I'll explain how to observe your subject matter and then, using a green pepper as an example, show you how to draw a preliminary sketch, add color to it, and how to draw a cross-section as well.

Sunflower (Gogh's Sunflower)
Helianthus annuus Asteraceae
This variety is among the sunflowers celebrated in the paintings of Vincent van Gogh.

Observing Plants

Botanical art is the ideal fusion of science and the arts. Your illustrations need to be accurate and unique, and that stamp of originality starts with the close observation and study of the specimens that catch your eye. Plants have evolved in diverse environments throughout the planet and transformed into many different species. Their forms are as fascinating as they are varied, offering an endless array of subjects for the botanical artist. One of the joys of creating botanical art is discovering this fusion of the observational and the aesthetic, elevating the beauty of nature that's already fully present before you.

Observing the Parts

When observing a plant, instead of looking at it as a whole, divide the body into four parts, if possible: flowers, fruit, leaves and stems. Observe each in order (if you are drawing the root system, don't forget to closely study that as well). For each key part, examine various aspects including the overall shape, how it's attached or appended and the structure. Develop an understanding of the plant's characteristics and how you're going to translate them to the page.

Botanical terms and keywords are of course helpful to learn along the way. These include flowers, fruit, leaves and stems. Learning the botanical terms will help sharpen your observation skills. Apply the terms while you're breaking down the specimen visually and identifying its component parts. Find a series of field guides and reference books, portable and otherwise, to consult and carry as you're observing plants and flowers in their natural settings. They'll prove indispensible resources, glossing and explaining botanical terms in an easy-to-understand way and providing a wealth of photographs and diagrams. Here's a quick overview of the four categories to be familiar with as a budding botanical artist.

FLOWERS To be able to draw flowers accurately, it's important to pay attention to the shape of the bloom, its arrangement and the order of the blooms, as well as the four main elements that comprise a flower (see page 39).

FRUIT There are various names for the fruiting bodies that trees and plants produce, including true fruit, false fruit, berries and dry fruit. Knowing the difference will most likely only come into play when creating technical drawings. Otherwise, in general, pay attention to the appearance of the surface and the shapes of the peduncle and calyx.

LEAVES This is such a common and widely divergent part, I'll explain the three elements of leaves from page 40 onward.

STEMS I focus on the appearance of the surface, the cross-sectional shape, and if there are vines, how they wind and the shape of the tendrils. This is the same for trees and shrubs, but pay attention to marks and patterns on the bark and leaves.

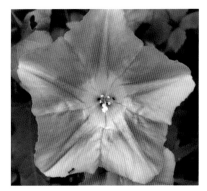

1 Sympetalous flower: The flower petals are joined together as one (Japanese bindweed).

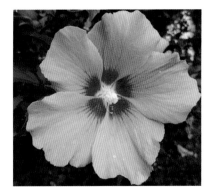

2 Polypetalous flower: The flower has separated petals (common hibiscus).

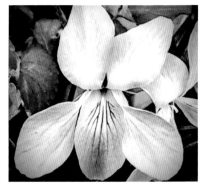

3 Zygomorphic flower: Viewed from the front, the left and right sides are symmetrical (Viola grypoceras).

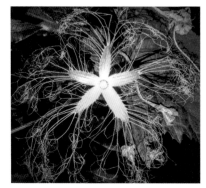

4 Actinomorphic flower: The lines of symmetry run in more than two directions (Trichosanthes cucumeroides).

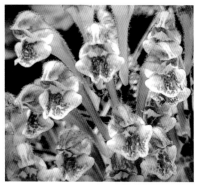

5 Tubular-shaped flowers with lip-like edges (Scutellaria indica).

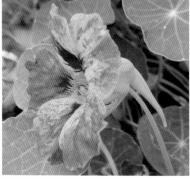

6 Flowers with tail-like spurs (Nasturtium).

7 Raceme: Flowers with peduncles stretch along the stem and bloom in order from the roots up (Asian lizard's tail).

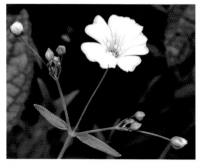

8 Spike: Flowers without peduncles are joined directly to the stem (Chinese spiranthes).

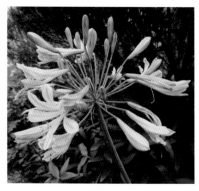

9 Umbel: Flowers are attached in a radial pattern (lily of the Nile).

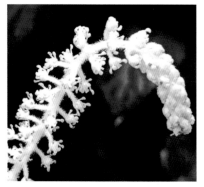

10 Capitulum: Looks like a single flower, but is actually made up of many flowers conjoined.

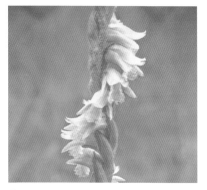

11 Cyme: The flower at the tip of the stem blooms first, and then the flowers at the top of the stems branching off at the base of the first stem bloom (Gypsophila).

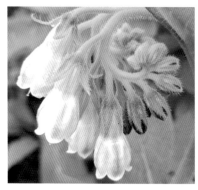

12 Whorl: Flowers are aligned in the shape of a snail shell (common comfrey).

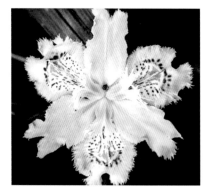

13 Trimerous flower: The four elements of the flower are in multiples of three. This is common in monocotyledonous plants (fringed iris).

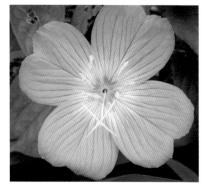

14 Tetramerous flower: The four elements of the flower are in multiples of four. This is common in dicotyledonous plants (pinklady).

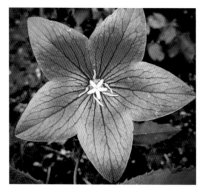

15 Pentamerous flower: The four elements of the flower are in multiples of five. This is common in dicotyledonous plants (Platycodon grandiflorus).

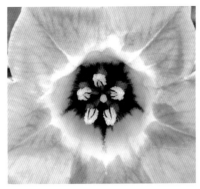

16 A flower with one pistil and five stamens around it (cutleaf groundcherry).

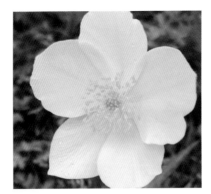

17 Flowers with multiple pistils (Anemone nikoensis).

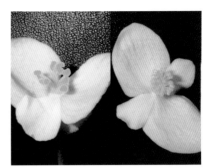

18 The flower on the left with only pistils is female, and the flower on the right with only stamens is male (hardy begonia).

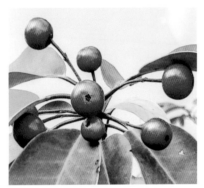

19 Fruit with long peduncles (longstalk holly).

20 Fruit with a striking green persistent calyx (gardenia).

21 Hairy stems: pay attention to the direction of the hairs (kudzu vine).

22 Stems with round cross-sections (hydrangea).

23 Stem with a square cross-section (Collinsonia japonica).

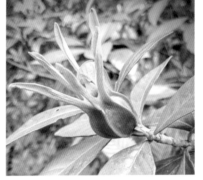

24 A vine that curls upward to the left (Skunkvine).

25 A vine that winds upward to the right (Japanese bindweed).

26 Vines twined around with curly tendrils (Smilax china).

27 A branch with winter buds. Leaf scars that look like animal faces; the white dots are lenticels (Japanese walnut).

The Parts of a Flower

When drawing flowers, what's most important is the shape, amount and positioning of each of the four elements. Observe these elements carefully and spend time drawing and redrawing each one. Depending on the type of plant, the elements giving the flower its characteristic shape can be multiples of 3, 4 or 5.

SEPAL The outermost part of the flower, which protects the interior when it's in bud. A set of sepals is called a calyx. Usually there are as many sepals as there are petals, and they're positioned between each petal. But in the case of flowers like tulips and lilies, the sepals are called the outer whorl and the petals are the inner whorl. They can sometimes develop larger than the petals, like the decorative flowers of delphiniums and hydrangeas.

PETAL Located inside the sepal, it protects the stamens and pistils. The collective conglomeration of petals is called a corolla. Calyx is another commonly used term you'll come across for this colorful part.

STAMENS Organs inside the petals that produce pollen. The type of plant determines how many there are and their positioning. Usually, they're made up of two parts.

ANTHERS Two pouches that hold pollen.

FILAMENTS Fine stalks that support the anthers.

PISTIL Located in the center of the flower, it's the typically three-part organ that produces seeds. The pistil becomes a fruit when fertilized, and the number, shape and position of the pistils during the flowering period relate to the shape of the fruit. With garden plants like the goldencup St. John's wort, which I use here as an example, the flowers tend to be large, making the difference in the four elements easy to understand. Wild plants often have small intricate flowers that can initially be confusing or more challenging to observe. Your powers of observation will gradually improve.

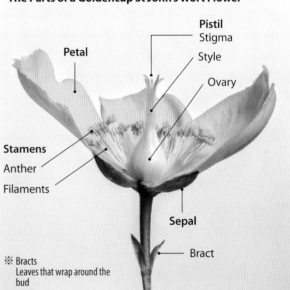

The Parts of a Goldencup St John's Wort Flower

Petal · Stamens · Anther · Filaments · Sepal · Bract · Pistil · Stigma · Style · Ovary

※ Bracts
Leaves that wrap around the bud

STIGMA The part that receives the pollen. The stigma is divided into the same number of segments as there are seed-bearing chambers in the ovary.

STYLE A cylinder-shaped part that supports the stigma.

OVARY Inside is an ovule and when pollinated and fertilized, the ovary becomes a fruit and the ovule becomes a seed. It's similar to a mammal's uterus.

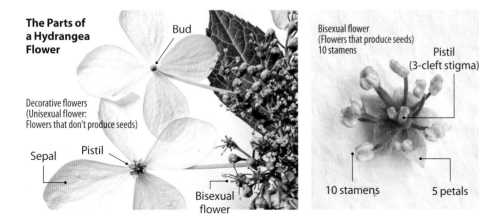

The Parts of a Hydrangea Flower

Bud · Decorative flowers (Unisexual flower: Flowers that don't produce seeds) · Sepal · Pistil · Bisexual flower

Bisexual flower (Flowers that produce seeds) 10 stamens · Pistil (3-cleft stigma) · 10 stamens · 5 petals

The sepals look like petals. A large developed flower that doesn't produce seeds in this way is known as an ornamental flower.

Viewed from the base, a leaf consists of the following three organs. Gaining a full understanding of the characteristics of these three parts is key to being able to drawing botanically accurate leaves.

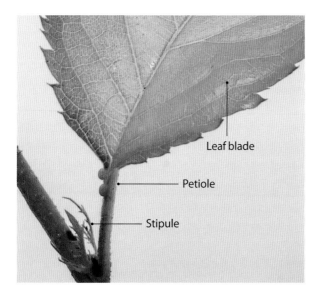

STIPULE These vary in shape and usually come in pairs. They're most often small, indistinct or fall off as the leaf matures, but in the case of pansies (see page 115) and peas, they can develop to be quite large.

PETIOLE This is the part that supports the leaf blade. The length varies depending on the plant species. Some have none at all.

LEAF BLADE This is the main part, essential for photosynthesis as well as displaying the characteristics of that particular species. Sizes and shapes vary, but most are symmetrical across the midrib. There are compound leaves that are divided into leaflets, but they're regarded are single leaf blades.

The veins, which are distributed throughout the leaf blade and transport water and nutrients, are formed into reticular veins and parallel veins. They're important to the botanical artist, as when shading is added to the leaf, they help create a three-dimensional effect. Observe them closely and practice accurately depicting them. The veins on the underside of the leaf are more visible, so they're easier to make note of.

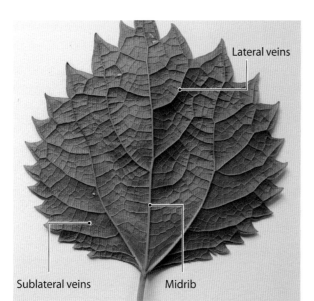

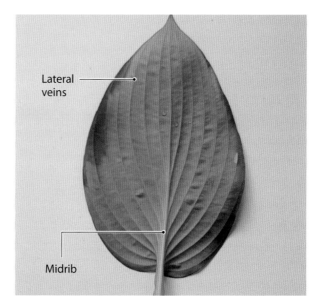

RETICULATED VENATION These are mainly on the leaves of dicotyledonous plants. In the center of the leaf blade is a midrib from which lateral veins branch off and become sublateral veins. It's important when drawing to note the lateral veins, as the characteristics vary according to the plant species.

PARALLEL VENATION These are mainly on the leaves of monocotyledonous plants. Some have lateral veins that run parallel to the midrib, while others run parallel after the lateral veins have branched off from the midrib. The parallel venation in the photo is the latter.

Simple and Compound Leaves

Leaves come in many different shapes and sizes, but they can be divided into either simple or compound leaves, depending on whether the leaf blade is joined together or separated. Once you're able to recognize the difference, you'll be able to draw leaves with botanical accuracy.

SIMPLE LEAF A leaf that has its three parts joined together by the same surface of the leaf blade (1–4). Some of them can be so deeply incised that they appear at first to be compound (3, 4).

COMPOUND LEAF A leaf that is divided into multiple leaves or leaflets (5–11). At first glance, it looks like one or more stems with leaves attached, but this is regarded as one leaf blade and so seen as one leaf. Some can be quite complex as they're subdivided into two or three layers. (6, 8, 9) To distinguish between a leaf (compound leaf) and leaflets, if there's a bud or flower at the base, the entire leaf from that base is a single leaf. The base of a leaflet doesn't bear buds or flowers.

1 Simple leaf (Japanese cherry).

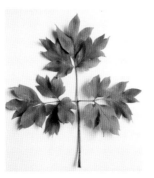

2 Trifoliate leaf (common hibiscus).

3 Pinnate leaf (chrysanthemum).

4 Palmate leaf (paperplant).

5 Trifoliate compound leaf; the blade is formed of 3 leaflets (Japanese wild parsley).

6 Double trifoliate compound leaf; the trifoliate compound leaf is in two layers (peony).

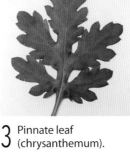

7 Pinnate compound leaf (rose).

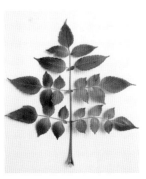

8 Double pinnate compound leaf (bell tree dahlia).

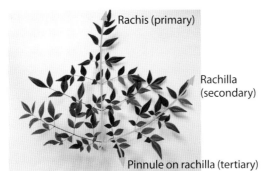

Rachis (primary)

Rachilla (secondary)

Pinnule on rachilla (tertiary)

9 Triple pinnate compound leaf (the pinnate compound leaf is in three layers. The tertiary layer is the same shape as the rose leaf in #7 (nandina).

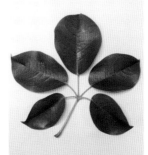

10 Palmate compound leaf; the leaflets radiate from a common point (Stauntonia hexaphylla).

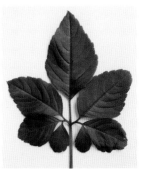

11 Pedate compound leaf; the leaflets radiate from different points (Causonis japonica).

Some leaves have jagged or serrated edges, while others have smooth or what's called entire edges. Observe them carefully and depict the edges as realistically as possible.

SERRATED Various sizes and shapes exist, many being single serrated (1, 2), but there are also more complex margins known as double serrated (3, 4). Even in the case of a single leaf, the size and shape at the base and at the tip often differ (1). Some lateral veins extend directly to the tip of the serrations (5), while others don't (6).

ENTIRE This is also known as all-sided (7). Even leaves that appear at first glance to be entire can have fine serrations and hairs (8, 9) so observe closely to learn the differences and distinctions.

1 Serrated (Sarcandra glabra).

2 Serrated (Mizunara).

3 Double serrated (Japanese kerria).

4 Double serrated (Japanese kerria, enlarged).

5 Mizunara (enlarged).

6 Sarcandra glabra (enlarged).

7 Entire (Fish mint).

8 Rhododendron oomurasaki.

9 Rhododendron oomurasaki (enlarged).

Leaves are attached to branches and stems in a variety of ways. The structure and the way they're attached is an important clue to identifying the plant, so be sure to note this carefully.

ALTERNATE Where one leaf is attached to the stem radiating at a certain angle (1).

OPPOSITE Where two leaves are attached to the node of the stem, facing each other at a 90° rotation. When the stem extends vertically, if viewed from above, it will have a characteristic cross-shaped appearance (2).

WHORLED Where three or more leaves are attached to the node of the stem (3).

ROOTS Some leaves, normally alternate, spread out radially from the ground with the stem barely showing (4). Some plants remain this way for life (the dandelion family and plantago), while the stems of other species develop later on (Philadelphia fleabane, common evening primrose). If the leaves are pinnately compound, they may appear opposite at first glance (5, 6). When looking at how the leaves are attached, it's essential to check the shape of a single specimen.

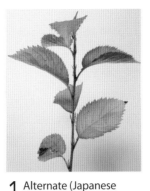
1 Alternate (Japanese cherry).

2 Opposite (Forsythia).

3 Whorled (October stonecrop).

4 Rosette in overwinter condition (common evening primrose).

5 This appears to be opposite, but is an example of alternate (black locust).

6 One black locust leaf (pinnate compound leaf).

Leaf Vein Rubbings and Pen Drawings

Making a rubbing, where the shape of an uneven object is transferred onto paper, allows you to replicate and more closely understand the intricate network of veins. Complete the rubbing by adding pen lines. This is especially useful for line drawings of leaves.

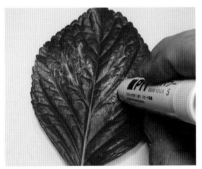
1 Place the leaf on one side of copier paper to decide the position and apply glue to the top side of the leaf.

2 Turn the leaf so the underside is facing up and glue it in place, and then fold the paper at the center to cover the leaf.

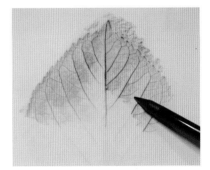
3 Press down with the palm of your hand so that the leaf sticks to the paper, and rub over the top with a graphite or 4B pencil.

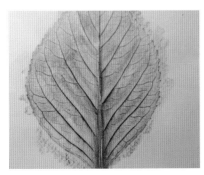
4 Here the rubbing is complete, and the leaf veins are evident. The thicker veins are more pronounced and apparent with their darker lines.

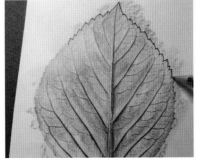
5 Add in the outline, midrib and lateral veins using a 0.5-mm pen. For the sublateral veins, use a 0.28-mm pen.

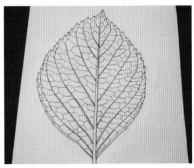
6 After adding the lines, use an eraser to remove the pencil and the drawing is complete. Save both the pressed specimen and the pen drawing.

Creating the Sketch

With botanical art, a rough sketch is made in pencil first, fleshing out the details before color is added. In principle, plants are drawn life-sized, but it's fine at first to draw them to any scale.

Sketch of a Green Pepper

Once you have decided the angle or perspective you want to draw, pick up the green pepper and examine the details while setting down your initial pencil strokes.

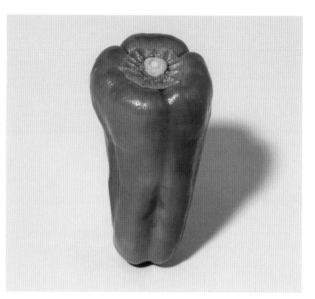

1 Draw the vertical center line of the green pepper.

2 Determine the position of the widest part.

3 Draw the rough outline of the entire green pepper.

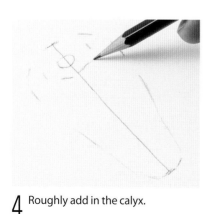

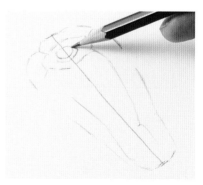

4 Roughly add in the calyx.

5 Draw the shape of the indents along the body.

6 Draw the shape of the cut stem on top of the calyx.

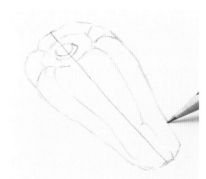

7 Join the outlines together to form the complete shape.

8 Gently press on the pencil lines using a kneaded eraser to remove stray marks and make the lines fainter.

9 Outline the shape of the calyx.

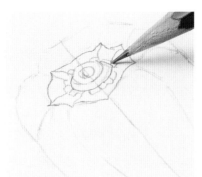

10 Add the surface details to the calyx, faithfully copying it.

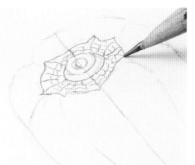

11 Add in the final layer of details.

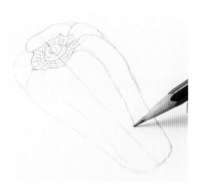

12 Indicate the swell or bulge along the body of the pepper.

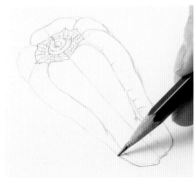

13 Ensure the outlines are solidly joined together.

THE COMPLETED SKETCH

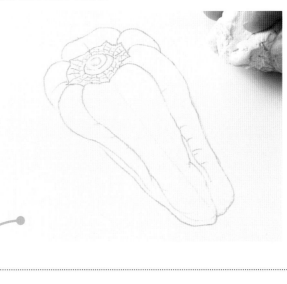

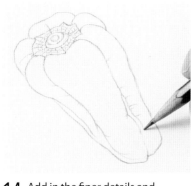

14 Add in the finer details and indicate the small indents.

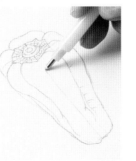

Erase the center line that was drawn at the start and then using a kneaded eraser remove the extra lines.

TIP

Adding Color

Once the sketch is completed, make the lines fainter with a kneaded eraser, then add color. Start by painting the outline, add shading to create a three-dimensional look before coloring and layering (page 48). Here the challenge lies in rendering and expressing the smooth, shiny texture of the green pepper.

- ○ **Deep Yellow**
- ● **Purple (Mineral Violet)**
- ● **Burnt Sienna**
- ● **Sap Green**
- ● **Hooker's Green**
- ● **Prussian Blue**
- ● **Black (Peach Black)**

Adding Color to a Green Pepper

OUTLINE

1 Mix Sap Green and Black to create a color close to that of a green pepper and using a size 1 brush, color the outlines in the sketch.

2 Here, the calyx has been colored.

3 Add color to the body too.

4 Here, all the lines have been colored.

SHADING

5 Dilute Burnt Sienna in water and add shading. Use a size 3 brush to paint the body.

6 Leave a circle uncolored for the highlight.

7 Apply slightly darker diluted Burnt Sienna to the shading of the creases.

8 Add shading along the shape of the creases.

> If you want the paint to dry quickly, use a hair dryer.
>
> **TIP**

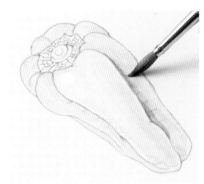

9 Mix and dilute Purple into Burnt Sienna and make the shading darker.

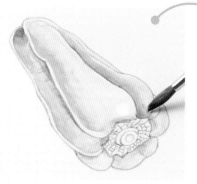

10 Darken the shading along the creases.

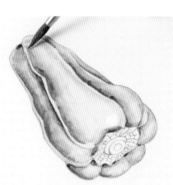

Apply color along the creases and, with a different brush dampened with water, blur it to create natural shading. **TIP**

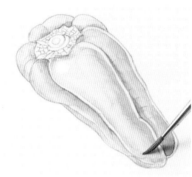

11 Add shading to the bottom of the green pepper too.

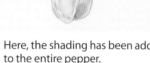

12 Here, the shading has been added to the entire pepper.

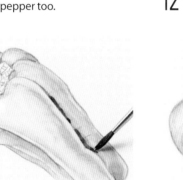

13 For the shadow of the creases, use dark Burnt Sienna mixed with Purple to add more shading.

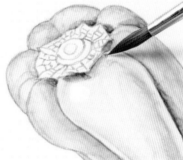

14 Add shading to the base of the calyx.

15 Add shading along the creases. Leave the edges of the outline that will form the highlight uncolored.

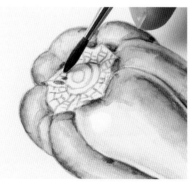

16 Add fine shading to the calyx.

17 Add shading to the cut stem of the calyx.

18 Here, dark shading has been added to the entire pepper.

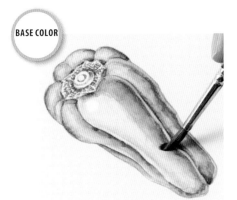

19 Lightly color the body using Prussian Blue.

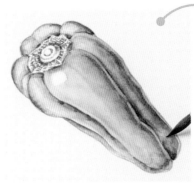

20 Leave the circle for the highlight uncolored.

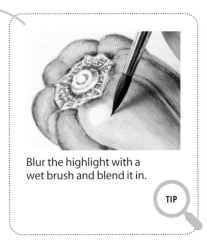

Blur the highlight with a wet brush and blend it in.

TIP

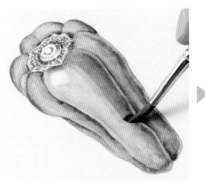

21 Lightly color the body with Sap Green.

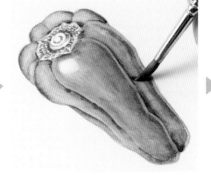

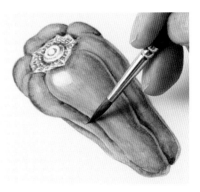

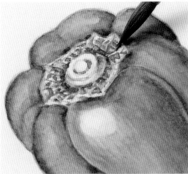

22 Color the stem using Sap Green.

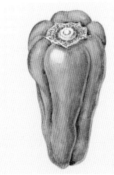

23 It's starting to look a lot like a green pepper.

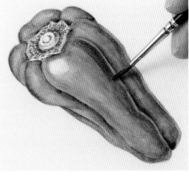

24 Color and layer the body with Hooker's Green.

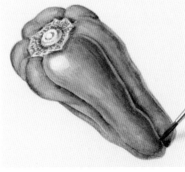

25 Color and layer along the calyx.

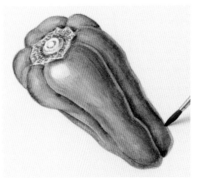

26 Color and layer the contours.

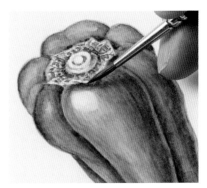

27 Color and layer the base of the calyx.

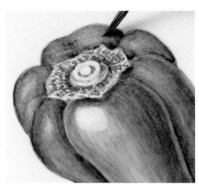

28 Color and layer the other side of the body too.

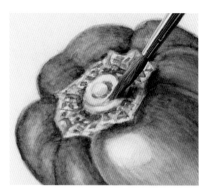

29 Color the cut stem of the calyx using Deep Yellow.

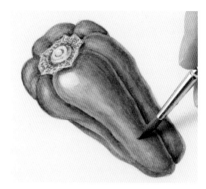

30 Color and layer the bright-looking areas using Deep Yellow.

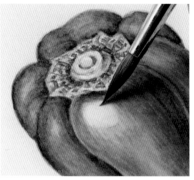

31 Color around the highlight with Prussian Blue and adjust the shape.

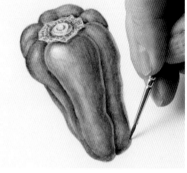

32 Color in any missing areas.

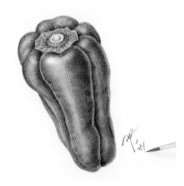

33 Add your signature in a place that helps balance your artwork.

THE COMPLETED ARTWORK

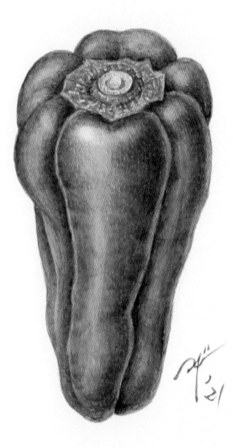

Green Pepper (Solanaceae)

Drawing a Cross-Section

In botanical drawings, while the characteristics and details of the plants are drawn accurately, cross-sections and enlarged diagrams are sometimes added for clarification of the characteristics and forms. Here I'll show you how to draw a cross-section of a green pepper.

- ⬤ Yellow Lemon
- ⬤ Purple (Mineral Violet)
- ⬤ Burnt Sienna
- ⬤ Sap Green
- ⬤ Hooker's Green
- ⬤ Prussian Blue
- ⬤ Black (Peach Black)

Cross-Section of a Green Pepper

These are horizontal and vertical cross-sections of a green pepper. Note the differences between the two views or vantage points.

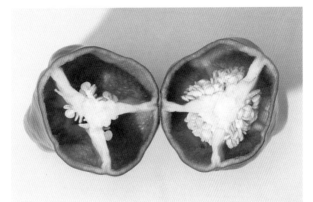

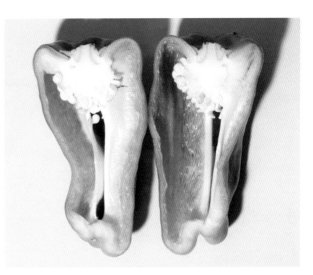

1 Make a sketch of both the horizontal and vertical cross-sections.

2 To help think about the composition that combines various treatments of the pepper on page 45, copy the sketches, then cut them out.

3 Arrange the cut-outs on the paper and think about the composition.

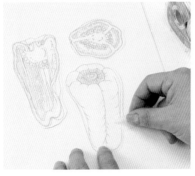

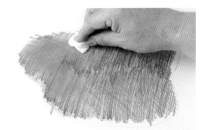

4 Once the composition is decided, tape the elements to the paper.

5 Copy the composition in step 4 and then on the back of the tracing paper, use a 4B pencil to coat the shape of the motifs to prepare it for tracing.

6 Once you've changed the direction of the pencil line and sufficiently coated the paper, gently rub with tissue paper to spread the graphite dust evenly.

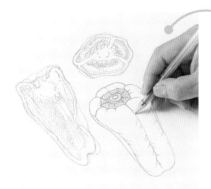

When tracing with the pen, be careful not to apply too much pressure. Use a water-based pen in a color other than black (like gold or red) so that it's easy to see where you've traced.

TIP

7 Lay the tracing paper face-up on the paper you'll use and trace the lines of the sketch using a gold pen.

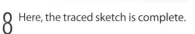

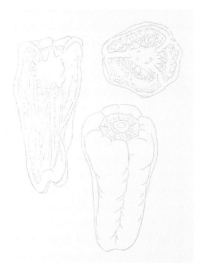

8 Here, the traced sketch is complete.

9 Use the actual object and the rough sketches to create a detailed line drawing.

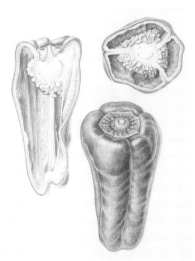

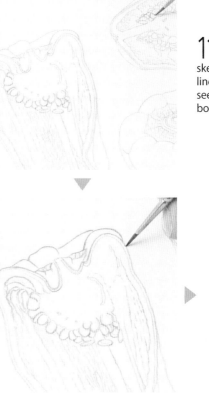

11 Use a kneaded eraser to make the lines of the completed sketch fainter and add color to the lines. With a size 1 brush, draw the seeds using Burnt Sienna and the body using Sap Green.

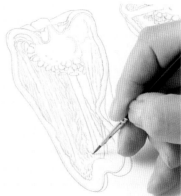

10 Make a copy of the finished line drawing and add shading with a pencil. It can then be used as a reference for shading when adding color (see page 98).

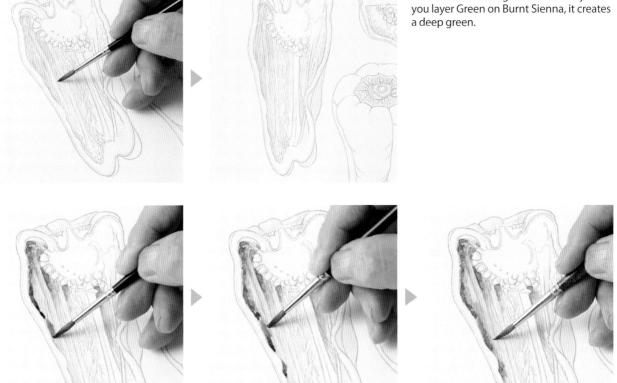

12 With a size 3 brush, use Burnt Sienna to add shading inside the body. If you layer Green on Burnt Sienna, it creates a deep green.

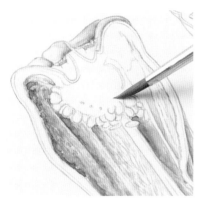 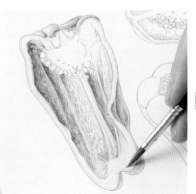 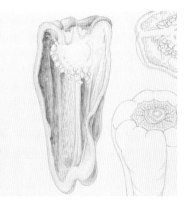

13 Add darker shading. Mix Burnt Sienna into Purple to create light and dark colors and apply the dark color. Then, with a different brush, apply the light color and spread out the dark color while blurring and blending it in.

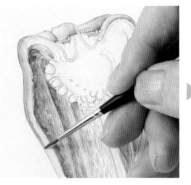

14 Lightly color the cut area using Prussian Blue.

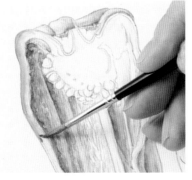

15 Color the inside of the body and the cut area with Lemon Yellow.

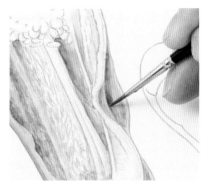

16 After adding Hooker's Green to the edges of the cut area, mix Hooker's Green and Lemon Yellow and, using a different paintbrush, apply that color and blur it. Color the base of the calyx in the same way.

17 Color the indent of the body using Hooker's Green.

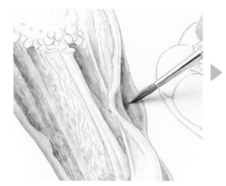

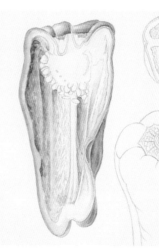

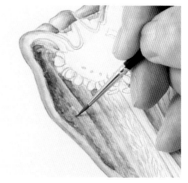

18 In the same way as step 16, blur here using the combined color of Hooker's Green and Lemon Yellow.

19 Mix a small amount of Black into Sap Green and Prussian Blue, and then apply it inside the body.

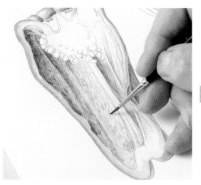

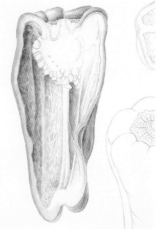

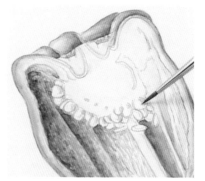

20 Make the color in step 19 lighter and add that inside the body too.

21 Mix Purple and Burnt Sienna and add shading to the seeds.

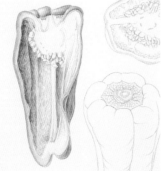

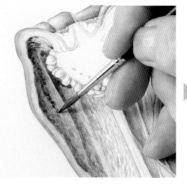

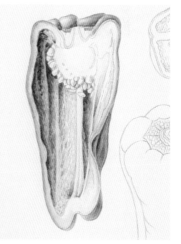

22 It's getting very near completion.

23 Mix Prussian Blue into the color in step 19 to make it darker and apply it inside the body to highlight the uneven parts.

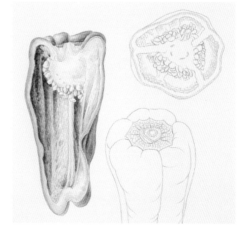

24 Mix Hooker's Green and Lemon Yellow and apply it to the cut area. Use a dry brush to blend it in.

25 Draw the horizontal cross-section in the same way.

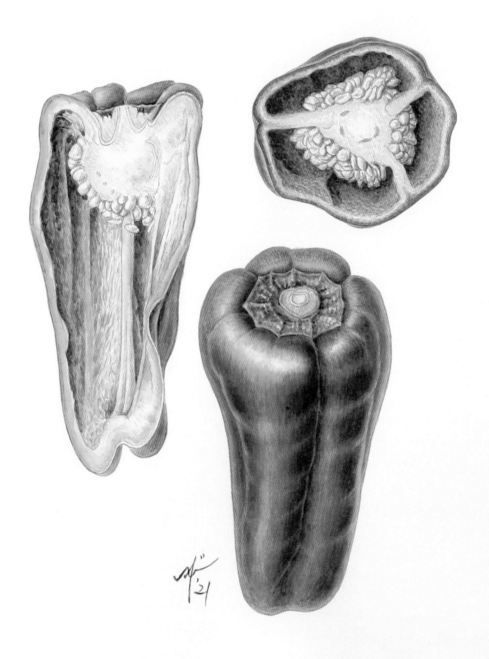

Green Pepper: Body and Cross-Sections (Solanaceae)

Practical Lessons in Botanical Art

Ready to get going? Here I'll give a detailed explanation of the process used when drawing various plants from gerberas, roses and hydrangeas to succulents, wildflowers and nuts. I'll also carefully explain how to draw using pens and colored pencils, along with how to create balanced, elegant compositions.

Tiger Lily (Liliaceae)
Lilium lancifolium
This flower is sometimes called Tenko-yuri (canopy lily). It has 33 tepals (petals and sepals) in total.

Drawing a Gerbera

Gerbera flowers, with their daisy-like blooms on top of long stems, have a striking appearance. Ray florets spread out from a central disc-shaped bed.

- ◯ Lemon Yellow
- ◉ Deep Yellow
- ◉ Opera
- ● Rose Madder
- ◉ Purple (Mineral Violet)
- ◉ Burnt Sienna
- ◉ Sap Green
- ◉ Hooker's Green

Creating the Sketch

1 Think about the composition and how much you want to include from the tip of the flower to the stem. Then draw pencil lines, as well as a small circle, in the center of the flower to mark it.

2 Draw a line from left to right to act as a guide for the size of the flower.

3 Draw lines that act as markers for the top, bottom, left and right tips of the flower.

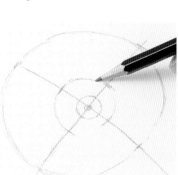

4 Join the lines you've marked in a circle and roughly draw the shape of the flower.

5 Draw border lines for the center. This is the range of the flower bed that supports the flower.

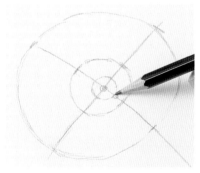

6 Determine the center of the flower bed and draw a small circle to mark it. It's slightly lower than what appears to be the center.

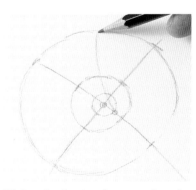

7 Start by drawing the center line of one ray floret from the center of the flower bed.

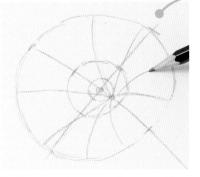

8 Draw another center line that will act as a guide for the position of the ray florets.

Draw a marking center line for each block.

TIP

56

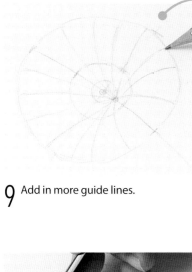

9 Add in more guide lines.

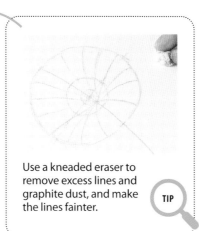

Use a kneaded eraser to remove excess lines and graphite dust, and make the lines fainter. **TIP**

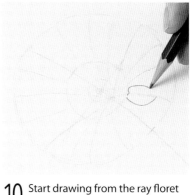

10 Start drawing from the ray floret that stands out at the bottom right.

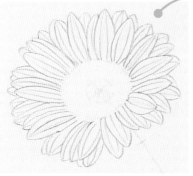

11 Draw the ray florets in symmetrical positions.

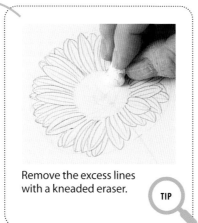

12 Draw the ray florets that are in central positions on each side.

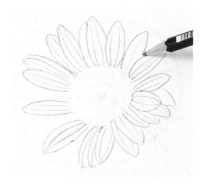

13 Draw the ray florets that are between them to fill the gaps.

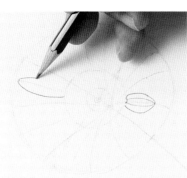

14 Here all the ray florets have been drawn.

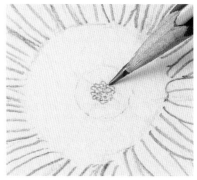

Remove the excess lines with a kneaded eraser. **TIP**

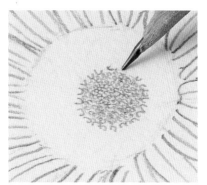

15 Draw the part where the central tubular flowers are gathered.

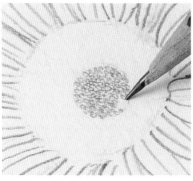
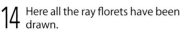

16 Draw more tubular flowers.

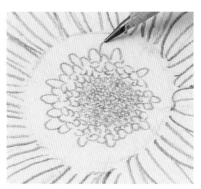

17 Add small ray florets around them.

18 Then add slightly larger ray florets around those.

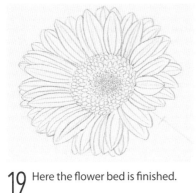

19 Here the flower bed is finished.

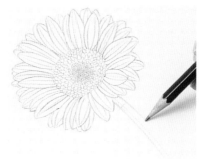

20 Draw a stem extending from the center of the flower head.

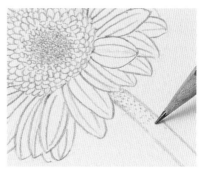

21 Draw the downy hairs growing on the stem.

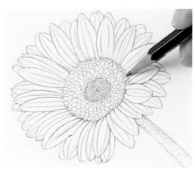

22 Clearly draw the border line of the flower bed.

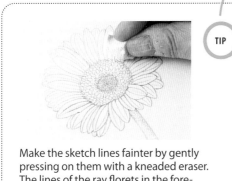

TIP

Make the sketch lines fainter by gently pressing on them with a kneaded eraser. The lines of the ray florets in the foreground should be slightly darker than those in the background.

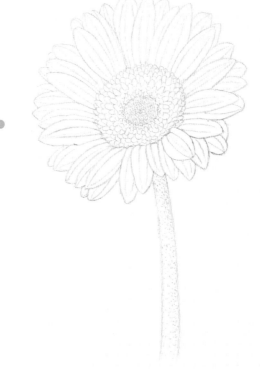

Creating the Sketch

OUTLINE

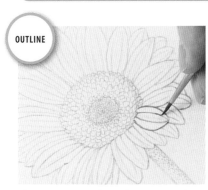

1 Mix Opera and Purple to create the color and then use a Size 1 brush to draw the outlines of the ray florets.

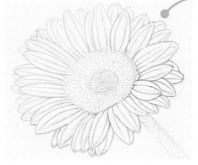

2 Do the same as in the sketch and make the lines of the ray florets in the foreground slightly darker than those at the back.

When applying color, it's a good idea to put tissue paper under your hand so that the paper doesn't get dirty.

TIP

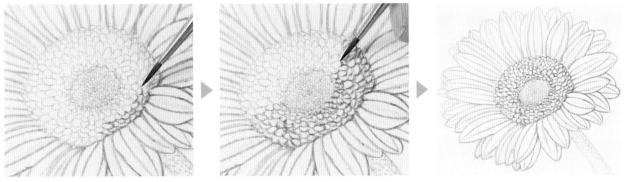

3 Draw the small ray florets using the same color as the surrounding ray florets. The sketch lines will be erased later, so don't worry if you deviate from those lines.

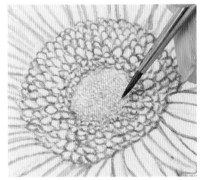

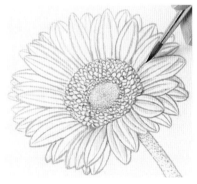

4 Draw the stem using Sap Green. Stipple the area near the flower (see page 30).

5 Draw the downy hairs on the stem.

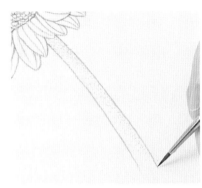

SHADING

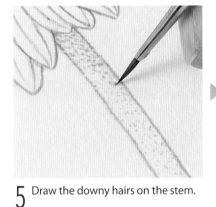

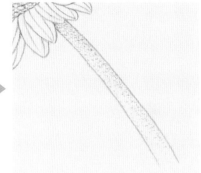

6 Draw the tubular flowers in the center using Sap Green.

7 With a size 3 brush, add light purple shading to the ray florets.

8 Add shading to each one of the ray florets.

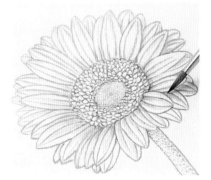

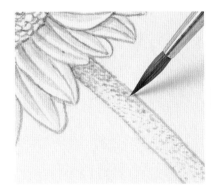

9 Add shading to the ray florets that overlap too.

10 Add shading to the stem using Burnt Sienna. It has downy hairs, so use stippling.

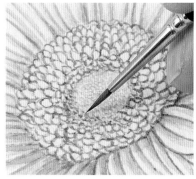

11 With a size 1 brush, add Burnt Sienna shading to the tubular flowers too.

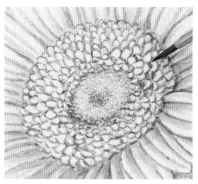

12 Use Purple to add shading to the surrounding small ray florets.

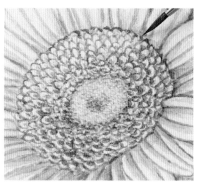

13 Add Purple shading to the border line of the flower bed too.

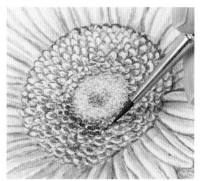

14 Then add more shading to the small ray florets.

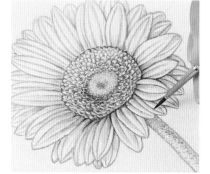

15 Using Purple, darken the lines of the ray florets in the foreground.

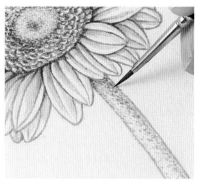

16 Using stippling, add Purple to the stem too.

BASE COLOR

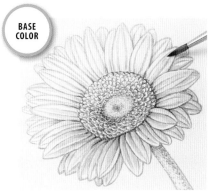

17 Using a size 3 brush, color the ray florets with light Opera.

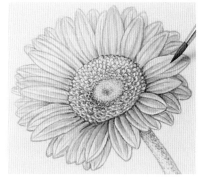

18 Apply Opera along the veins of the ray florets in the foreground.

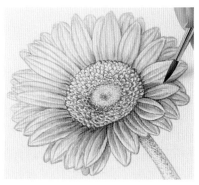

19 Mix Rose Madder into Opera and use that color to darken the shading of the ray florets.

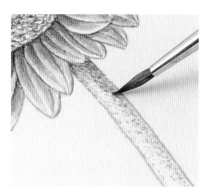

20 Mix Hooker's Green into Sap Green and use that color to stipple the stem.

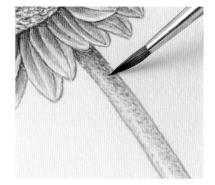

21 Next, apply a darker color.

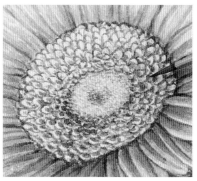

22 Use Purple to add shading to the small ray florets.

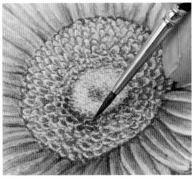

23 Add more shading using Rose Madder.

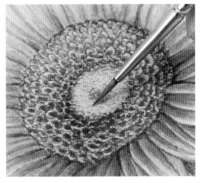

24 Mix Sap Green into Lemon Yellow and with a size 1 brush, color the tubular flowers.

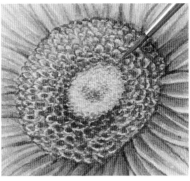

25 Color the surrounding small ray florets as well.

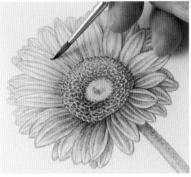

26 Mix Deep Yellow into Rose Madder and color the ray florets.

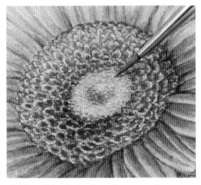

27 Add a little Sap Green to the tubular flowers.

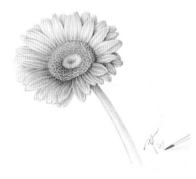

28 Add your signature to complete the work.

THE COMPLETED ARTWORK

Gerbera
(Asteraceae)

Drawing a Daffodil

This is also called trumpet narcissus, and as the name suggests, it has a unique flower shape with a central part that protrudes like a trumpet. The sleek long, thick leaves are also characteristic.

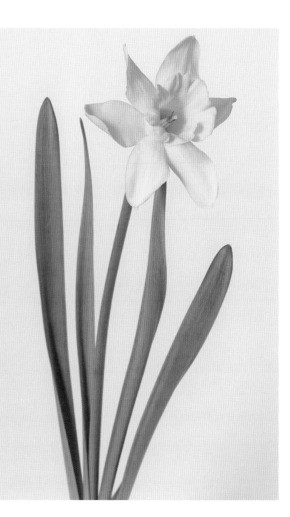

○ White (Titanium White)
 Lemon Yellow
● Deep Yellow
● Opera
● Purple (Mineral Violet)

● Burnt Sienna
● Sap Green
● Hooker's Green
● Prussian Blue
● Black (Peach Black)

Creating the Sketch

1 Draw the center line of the stem and flower (the line running from the stem through to the tip of the pistil) and also the center lines (midribs) of the leaves.

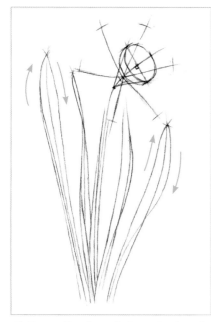

2 Draw a line through the perianth and the center of the central trumpet-shaped subcorolla. Draw the leaves starting from the front edges and going toward the back edges.

3 Draw the rough shape of the perianth and the sub-corolla.

4 Once done, make the whole area fainter with a kneaded eraser.

5 Draw a rough sketch using clear lines and draw in the central sub-corolla and the folds of the perianth.

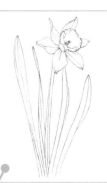

Make a copy of the sketch and, using a pencil, add shading to act as a reference when adding color (see page 98).

TIP

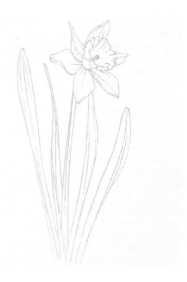

6 Before adding color, make the sketch lines fainter with a kneaded eraser. As you work down, gradually make them fainter and fainter.

THE COMPLETED SKETCH

Adding Color

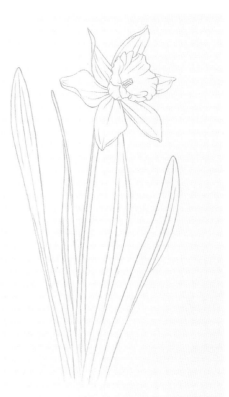

1 Mix Deep Yellow, Burnt Sienna and White and draw the outline of the flower using a size 1 brush.

2 Mix Sap Green, Prussian Blue and White and use that color to draw the outlines of the leaves.

3 Here color has been added to all the outlines.

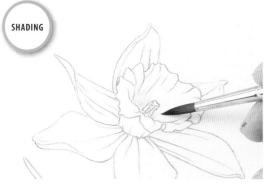

4 With a size 3 brush, add light Purple shading to the flower.

5 Mix Prussian Blue and Black and add shading to the leaves.

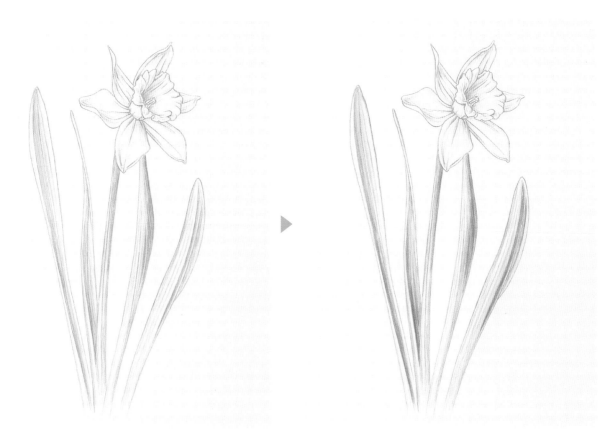

6 Here the shading has been added to the flower and leaves. Gradually darken the shading on the stem, referring to the shading on the copy made in step 5 on page 62.

BASE COLOR

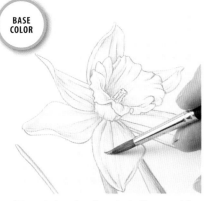

7 Lightly color the whole flower with Lemon Yellow.

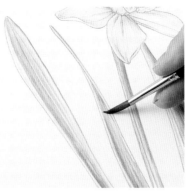

8 Color and layer Prussian Blue on the indented parts inside the leaves.

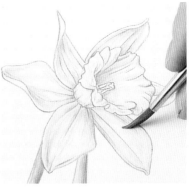

9 Color and layer along the folds of the flower with more Lemon Yellow.

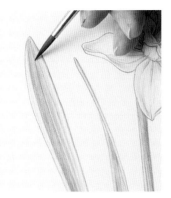

10 Mix Prussian Blue and Hooker's Green and layer that color on the leaves to make them darker.

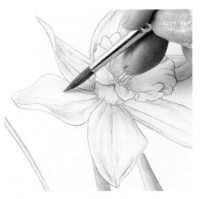

11 Mix Deep Yellow and Lemon Yellow and layer along the uneven parts of the flower to create a three-dimensional effect.

12 Mix Sap Green and Deep Yellow to color the bright areas of the leaves and stem.

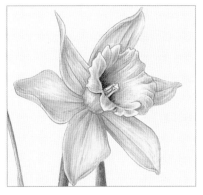

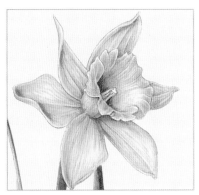

13 The lighter part of the leaves and stem create a contrast in color with the upper parts.

14 Emphasize the darker parts of the flower by using a color created by mixing Opera into Yellow Deep.

15 Finish by layering shading on the subcorolla.

THE COMPLETED ARTWORK

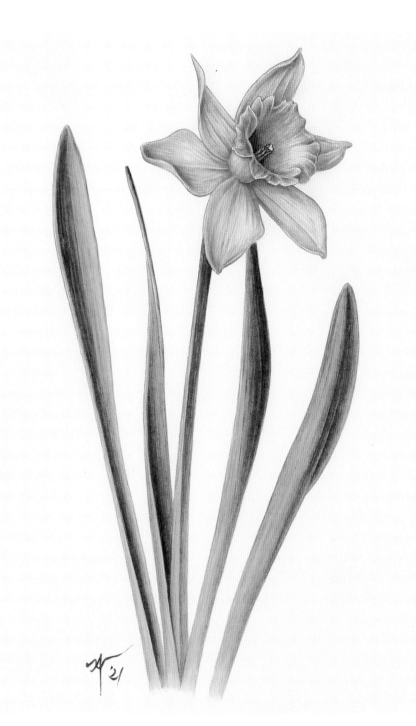

Wild Daffodil
(Amaryllidaceae)

Drawing a Rose

Roses come in many varieties, colors and shapes, but here the focus is on a classic, elegant deep red rose. The overlapping petals are more complex than those of a gerbera, so draw each petal clearly. The key to drawing the leaves is in the depiction of the veins and serrations.

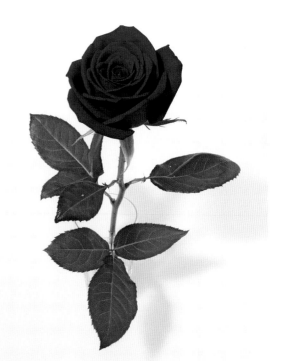

● Deep Yellow
● Opera
● Rose Madder
● Ultramarine Deep

● Sap Green
● Hooker's Green
● Prussian Blue
● Black (Peach Black)

Creating the Sketch

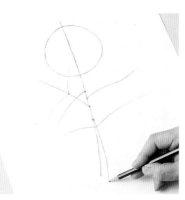

1 Decide the size of the paper according to the flower. Keep the leaves close to a minimum near the flower and draw the ones that are easy to understand as compound leaves.

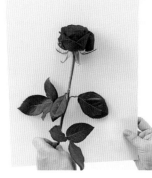

4B pencil

2 Draw a circle about the same size as the flower (the center of the circle will be two-thirds of the way down the paper), and lightly draw the line of the stem through the center of the flower.

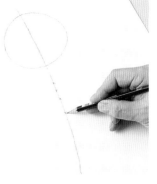

3 Mark the positions of the bases of the leaves on the stem.

4 Draw lines that go from the bases of the leaves along the midribs to the tip of the leaves. Roses have compound leaves, so draw lines through to the tips of the leaflets too and adjust the stem line, depending on the direction in which the leaves extend.

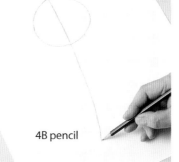

5 In the center of the flower, draw a horizontal line perpendicular to the line in step 2 and create an outline while paying attention to the pointed tips of the petals.

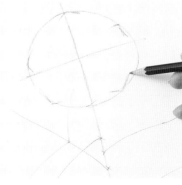

6 Mark along the crossed lines the approximate positions of the petals from the center of the flower out to the outline of the farthest petal.

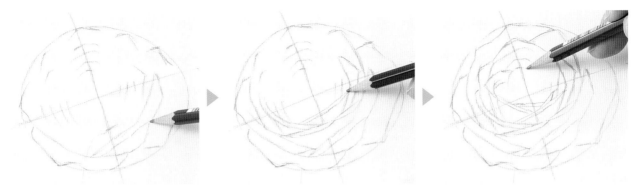

7 Using the markers as a guide, draw each petal, starting from the one at the front, so that they appear to wrap around the center. Start by drawing lightly.

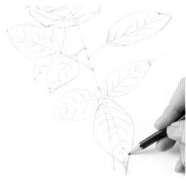

8 Here the central part of the flower has been drawn.

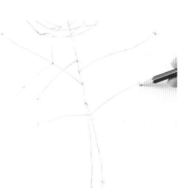

9 Next, draw markers to indicate the tips of the leaves.

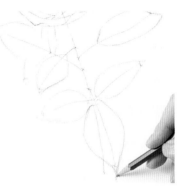

10 Draw the rough outlines of the leaves.

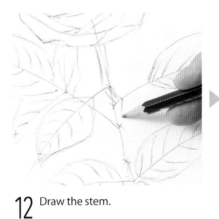

11 Roughly draw the lateral veins on the leaves.

12 Draw the stem.

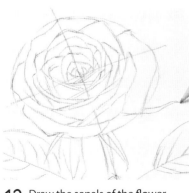

13 Draw the sepals of the flower.

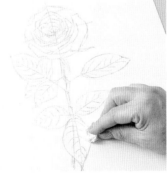

14 Once done, make the lines fainter with a kneaded eraser.

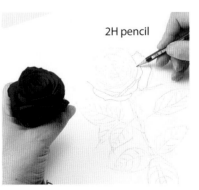

2H pencil

15 Draw the petals using firm lines, while carefully observing the flower.

THE COMPLETED SKETCH

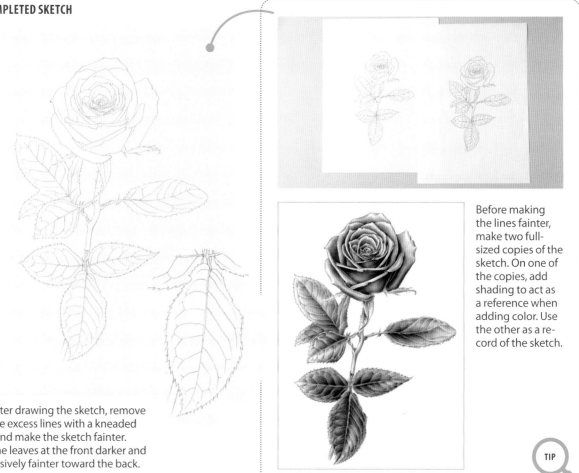

16 After drawing the sketch, remove the excess lines with a kneaded eraser and make the sketch fainter. Make the leaves at the front darker and progressively fainter toward the back.

Before making the lines fainter, make two full-sized copies of the sketch. On one of the copies, add shading to act as a reference when adding color. Use the other as a record of the sketch.

TIP

Adding Color

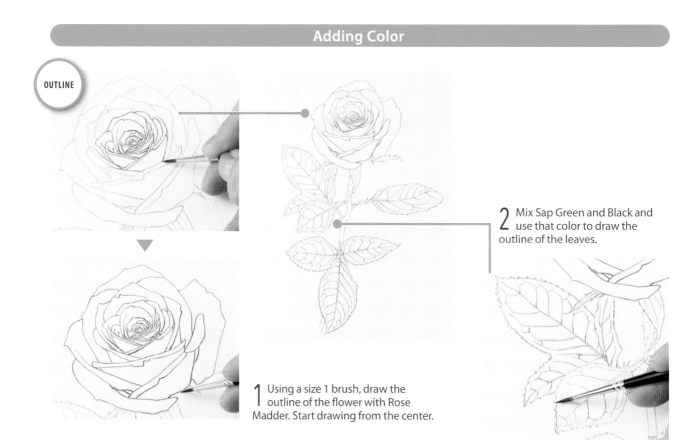

OUTLINE

2 Mix Sap Green and Black and use that color to draw the outline of the leaves.

1 Using a size 1 brush, draw the outline of the flower with Rose Madder. Start drawing from the center.

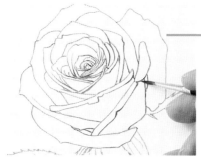

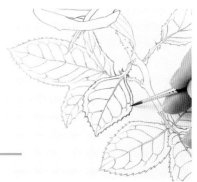

3 Color and layer the petals and shade in the foreground to add strength to the lines.

4 Color and layer the shade of the leaves too.

SHADING

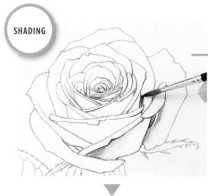

5 Mix Ultramarine Deep and Black to create a dark color and prepare a second lighter color with water. With a size 2 brush, apply the dark color to the shade of the flower and then immediately apply the lighter color using a size 3 brush, blurring the shaded area. Keep repeating this process of coloring and layering until you create a three-dimensional effect.

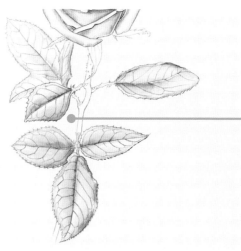

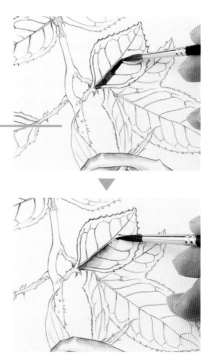

6 Mix Black and Prussian Blue and, in the same way as in step 5, prepare light and dark colors. With a size 2 brush, apply the dark color along the leaf veins and then immediately apply the lighter color using a size 3 brush to blur it. It's fine to turn the paper to make it easier to color.

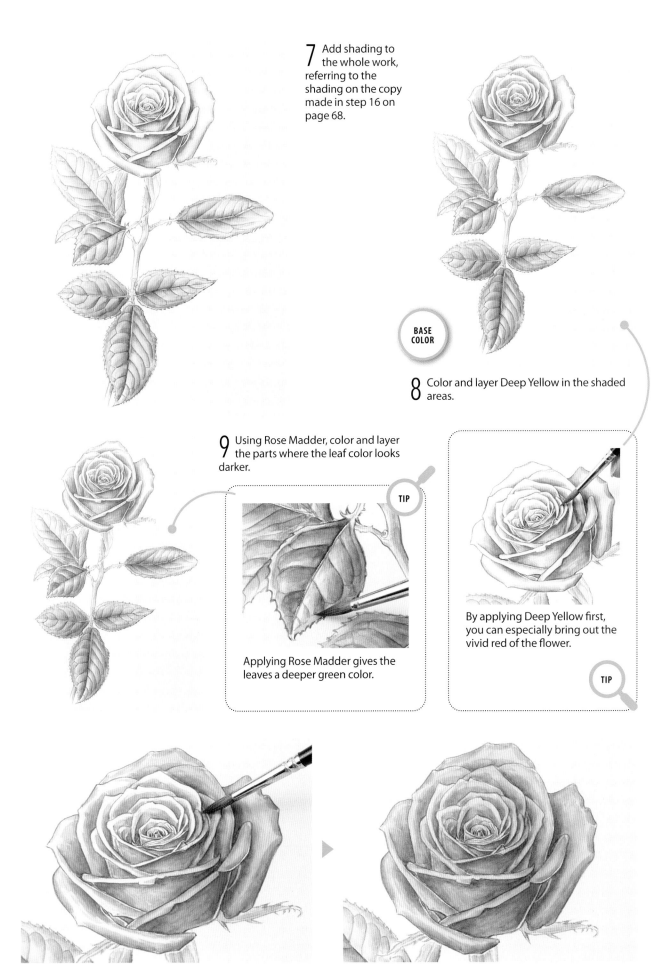

7 Add shading to the whole work, referring to the shading on the copy made in step 16 on page 68.

BASE COLOR

8 Color and layer Deep Yellow in the shaded areas.

9 Using Rose Madder, color and layer the parts where the leaf color looks darker.

TIP

Applying Rose Madder gives the leaves a deeper green color.

By applying Deep Yellow first, you can especially bring out the vivid red of the flower.

TIP

10 Color and layer the flower using light Opera.

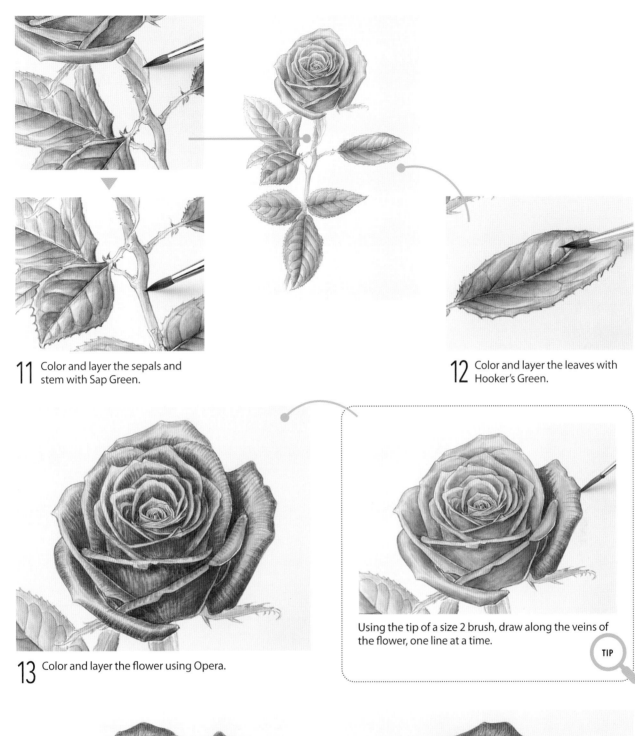

11 Color and layer the sepals and stem with Sap Green.

12 Color and layer the leaves with Hooker's Green.

13 Color and layer the flower using Opera.

Using the tip of a size 2 brush, draw along the veins of the flower, one line at a time.

TIP

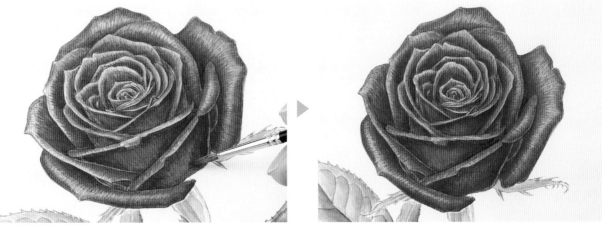

14 Color and layer using Opera. Layer the color at least three times so you can impart a realistic texture to the petals.

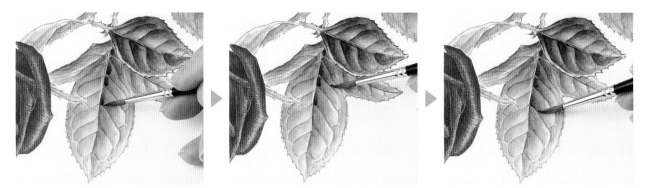

15 Mix Black, Prussian Blue and Hooker's Green and use that color to add more shading to the leaves. Color along the leaf veins and blur with a wet brush. Follow the same process as for the shading on page 69.

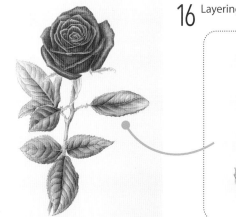

16 Layering the colors will get you closer to your desired color.

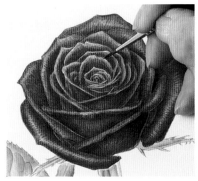

Layer the same color as used in step 15 to the leaf margins and add emphasis in places.

TIP

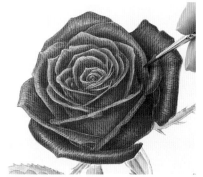

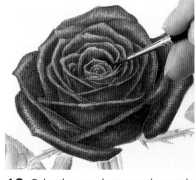

17 Color and layer Rose Madder where the petals overlap and add details to finish.

18 Use more Rose Madder to emphasize the petal edges.

19 Color the gaps between the petals and emphasize the shade.

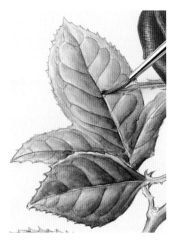

20 Color and layer Sap Green to the brighter areas of the leaves.

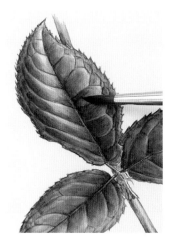

21 Color and layer Hooker's Green to the darker areas.

THE COMPLETED ARTWORK

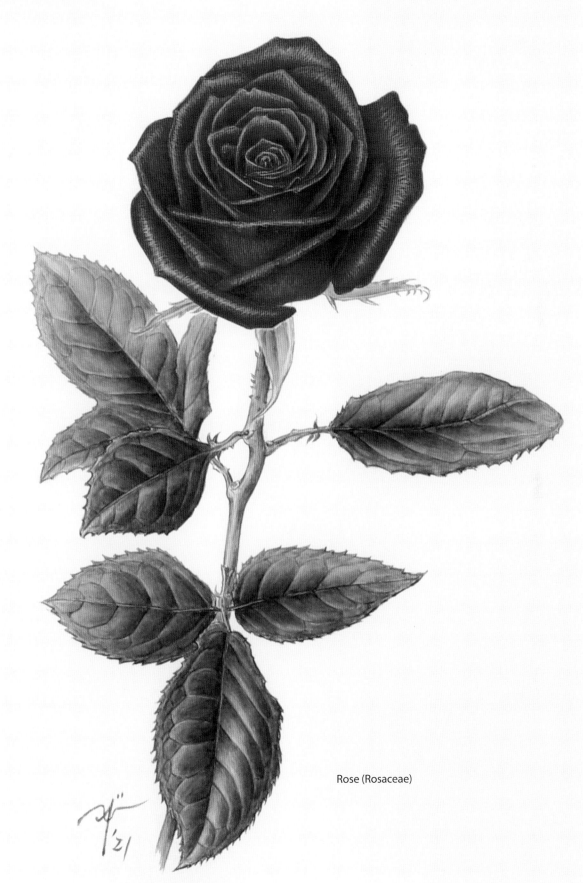

Rose (Rosaceae)

Drawing White Lilies

Asian hybrid lilies are created by crossbreeding Japanese endemic species such as the golden-rayed lily and the showy lily. When drawing white flowers, no white paint is used; instead, you make use of the white of the paper. Adding shading means the white can be enhanced three-dimensionally.

○ White (Titanium White)
 Lemon Yellow
● Rose Madder
● Purple (Mineral Violet)
● Ultramarine Deep

● Cerulean Blue
● Sap Green
● Hooker's Green
● Prussian Blue
● Black (Peach Black)

From Sketching to Adding Color

SKETCH

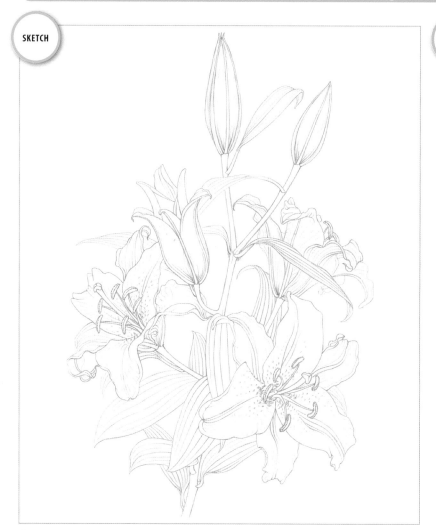

1 Here the sketch is completed. Draw clear, distinct lines.

OUTLINE

2 Mix Hooker's Green, Prussian Blue and Black and, using a size 1 brush, add that color to the outlines of the leaves.

3 Mix Sap Green and Deep Yellow for the buds, pistil and stamen filaments, and then mix White, Black and Ultramarine Deep to make gray and add it to the flowers.

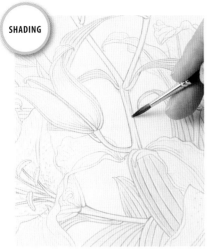

SHADING

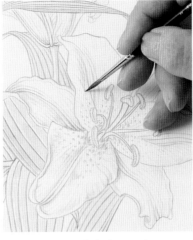

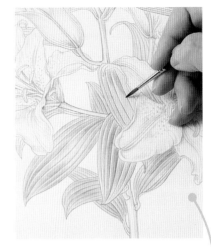

4 Mix Black and Prussian Blue, and with a size 3 brush, add shading across all the leaves and one side of the stem.

5 Mix White and Black to make gray and use it to add shading to the petals.

6 Mix Black and Prussian Blue, making it a little darker than the color in step 4, and use it to layer shading along the leaf veins.

BASE COLOR

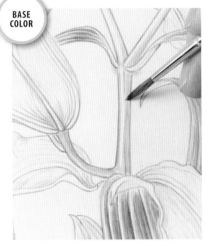

TIP

Place your little finger on the paper to steady it and draw using the tip of the brush. If you change the direction of the paper to add the shading under the leaf veins, you'll find it easier to draw.

7 Mix Sap Green and Lemon Yellow to color the stem. Layer the color along the shading and outlines initially added, leaving one side uncolored.

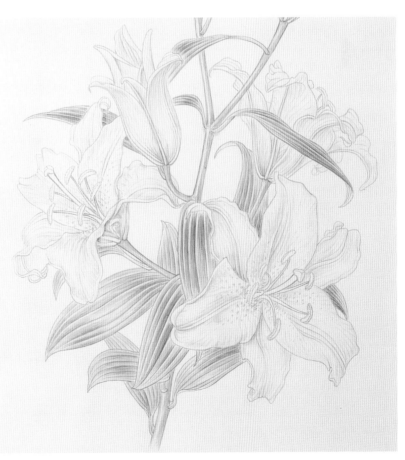

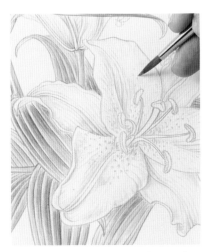

8 Mix Cerulean Blue into White and use that color to layer shading on the petals.

9 Here almost all the shading has been finished.

10 Color the bud with Lemon Yellow.

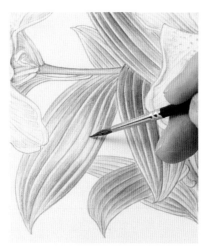

11 Color and layer Sap Green on the shading of the leaves. When doing this, leave the veins white.

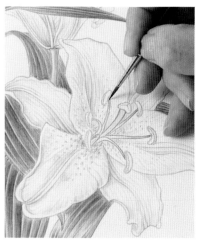

12 Using a size 1 brush, take the same color as in step 7 (Sap Green and Lemon Yellow) and paint the pistils and the bases of the anthers.

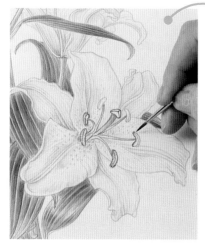

13 Mix Rose Madder and Purple, and use that color to outline the pistils and anthers.

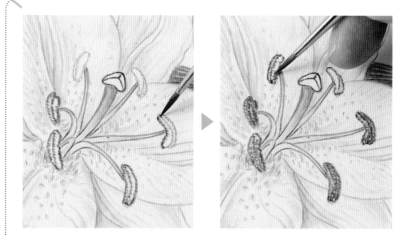

The anthers have pollen on them, so use stippling. Once you've drawn the outline, color the anthers using a mix of Rose Madder and Lemon Yellow, color the stigmas with Rose Madder and then darkly color with Ultramarine Deep.

TIP

14 Mix Sap Green and Hooker's Green and color along the veins of the buds.

15 Mix Hooker's Green, Black and Prussian Blue and layer that color on the leaves.

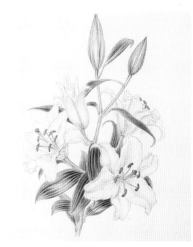

16 Color the midribs (top and underside) of the perianths using Lemon Yellow and adjust the details to complete the work.

THE COMPLETED ARTWORK

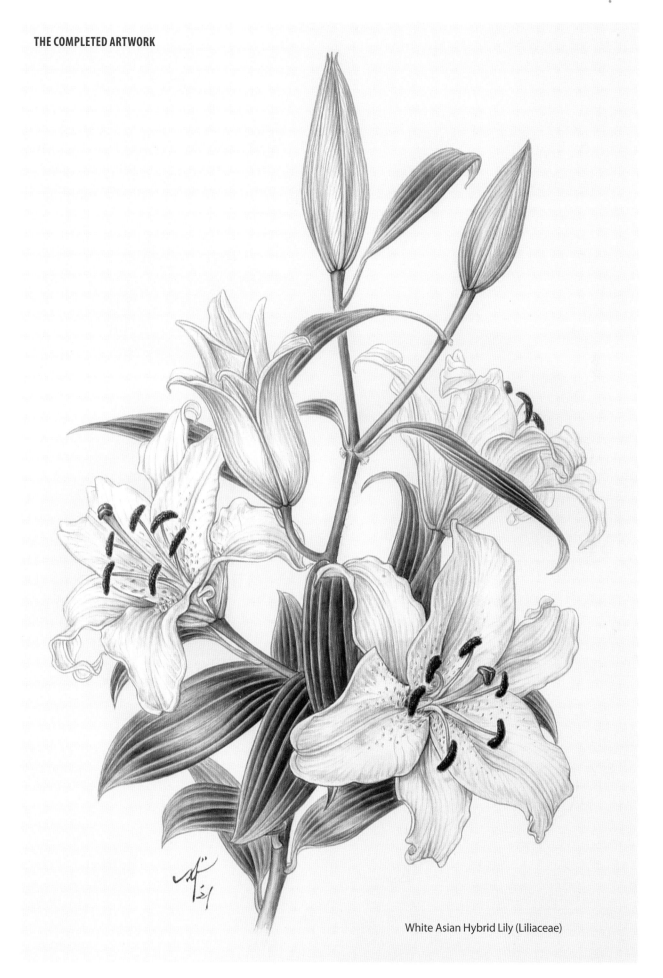

White Asian Hybrid Lily (Liliaceae)

Drawing Delphinium

Delphinium has beautiful blue flowers. While it's a potted plant with a lot of leaf-covered stems, you don't need to draw all of them. Choose the most characteristic stems and draw those. Focus on drawing a small number well rather than accurately reproducing a lot.

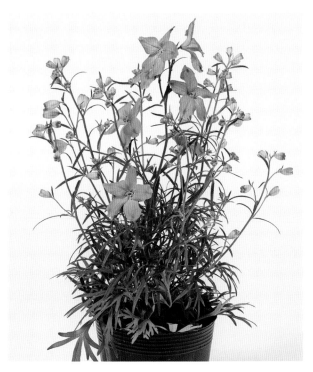

- Opera
- Purple (Mineral Violet)
- Ultramarine Deep
- Cobalt Blue
- Manganese Blue Nova
- Cerulean Blue
- Sap Green
- Hooker's Green
- Prussian Blue
- Black (Peach Black)

Creating the Sketch

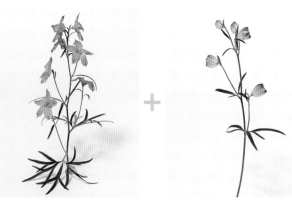

Choose stemmed flowers and buds from the potted plant and combine them to create a sketch. Make the lines fainter with a kneaded eraser and then add color.

Adding Color

OUTLINE

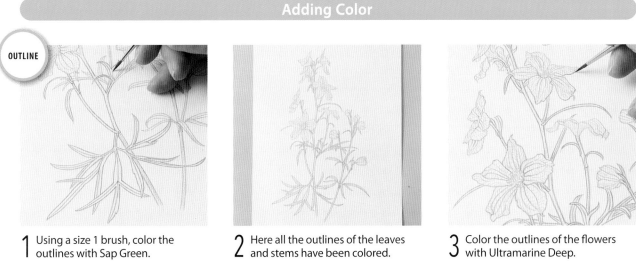

1 Using a size 1 brush, color the outlines with Sap Green.

2 Here all the outlines of the leaves and stems have been colored.

3 Color the outlines of the flowers with Ultramarine Deep.

SHADING

4 Mix Ultramarine Deep and Purple, and color the outlines of the buds.

5 Mix Prussian Blue and Black, and use a size 1 brush to add shading to the leaves. Color only one side of the leaf veins.

6 Using the same color as in step 5, color in the stem. The stems have hairs, so don't make the lines smooth. Instead have them breaking up along one side of the stems.

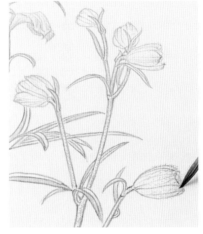

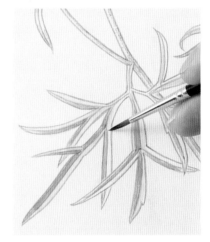

7 Mix Ultramarine Deep and Purple and using a size 3 brush, add shading to the sepals.

8 Mix Black into the color created in step 7 and add shading to the buds.

9 Mix Hooker's Green, Prussian Blue and Black and layer that color on the shading of the leaves added in step 5. Make this color lighter and add it to the uncolored side of the leaves too.

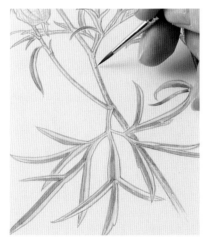

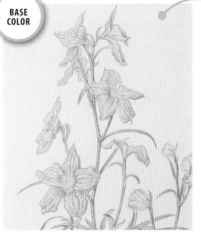

BASE COLOR

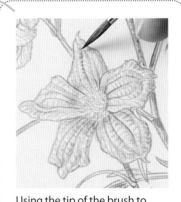

10 Using a size 1 brush, take the same color as in step 9 (the dark color) and color and layer the stems.

11 Using a size 3 brush, color along the perianth veins with Cobalt Blue.

Using the tip of the brush to draw the fine veins of the perianth means you can capture the delicate texture of the sepals.

TIP

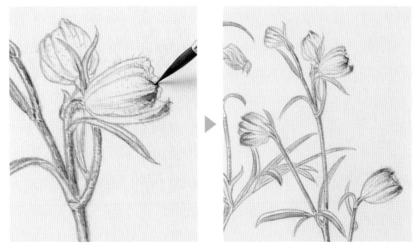

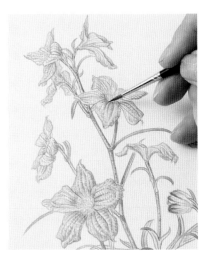

12 Mix Ultramarine Deep and Purple, and color the dark areas of the buds. There are downy hairs, so use stippling.

13 Color the dark areas of the sepals with Cerulean Blue, and keep layering until you get the color you want.

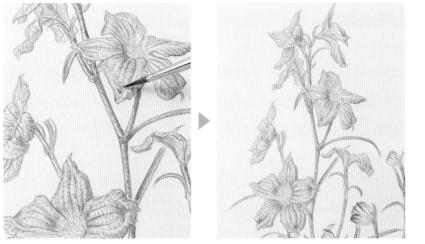

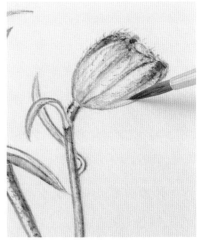

14 Using a size 1 brush, color the flecks on the sepals with Opera.

15 There are downy hairs on the buds, so stipple with Sap Green.

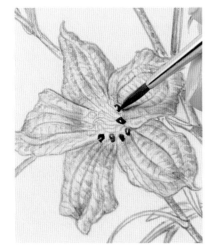

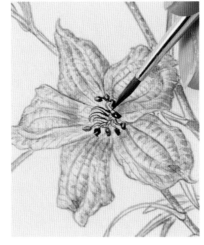

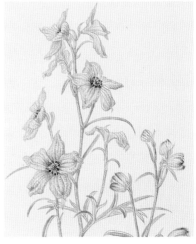

16 Mix Purple and Black, and color the stamen anthers.

17 One by one, carefully draw each of the central pistils and the stamen filaments.

18 Once you've finished drawing all the pistils and filaments, layer with more Manganese Blue Nova and adjust the details to complete the work.

THE COMPLETED ARTWORK

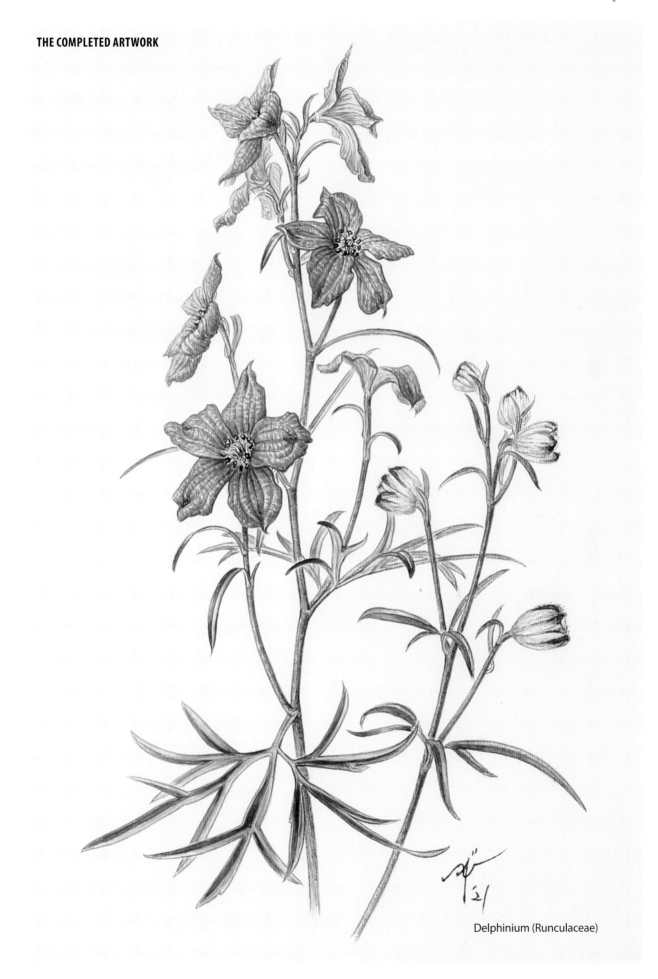

Delphinium (Runculaceae)

Drawing a Hydrangea

Synonymous with spring, this old-fashioned bloom is enjoying a comeback. The parts that look like petals are developed sepals, and the small round grains in the center are corollas or flower clusters that haven't opened yet. You don't need to draw all of the ball-like blooms, select a few to focus on. The cut flowers don't retain their integrity for long, so leave them potted and cover the parts you're not interested in with tissue paper. Here, I drew the two inflorescences shown in the bottom right photo.

- Lemon Yellow
- Deep Yellow
- Opera
- Purple (Mineral Violet)
- Ultramarine Deep
- Cobalt Blue
- Manganese Blue Nova
- Cerulean Blue
- Sap Green
- Hooker's Green
- Prussian Blue
- Black (Peach Black)

From Sketching to Adding Color

SKETCH

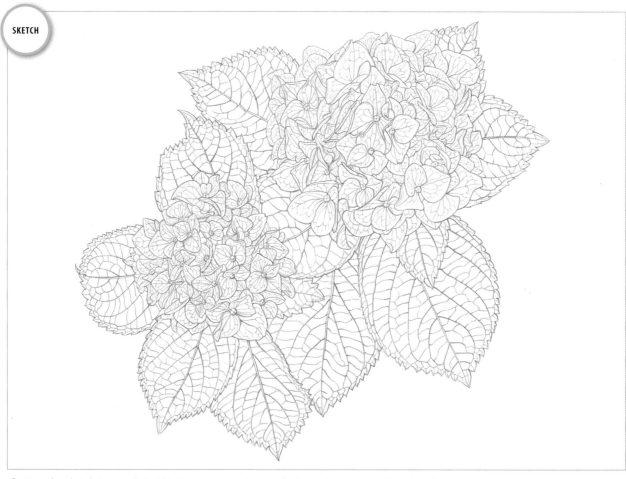

1 Here the sketch is completed. It's important to draw each shape thoroughly using clear lines.

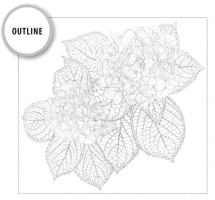

OUTLINE

SHADING

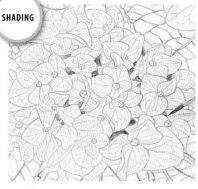

2 Using a size 1 brush, color the outlines of the leaves with Hooker's Green.

3 Color the inflorescences with Cerulean Blue and the small flowers with Lemon Yellow.

4 Mix Black and Ultramarine Deep, and, with a size 2 brush, use that color to fill the gaps between the sepals.

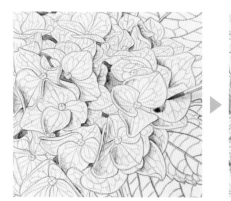

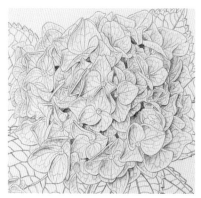

5 Mix Purple and Ultramarine Deep to create dark and light colors and use them to add shading to the inflorescences. Apply the dark color and then, with a different brush, add the light color and blur it in.

6 Here all the shading has been added to the flowers.

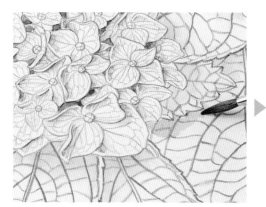

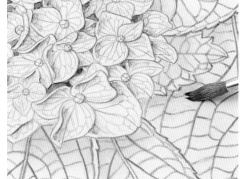

7 Mix Black and Prussian Blue and use that color to add shading to the overlapping parts of the inflorescences and leaves, then blur it in with a different, wet brush.

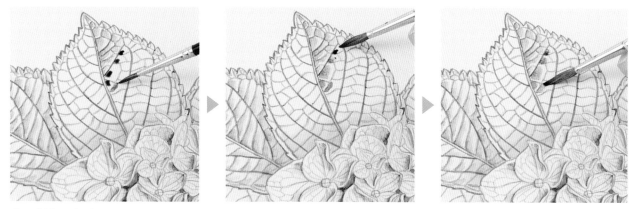

8 Add fine shading to the leaves. Using the color in step 7, create dark and light colors. Apply the dark color along the leaf veins and then, with a different brush, add the light color and blend it in. The paper has been turned upside down here to make it easier.

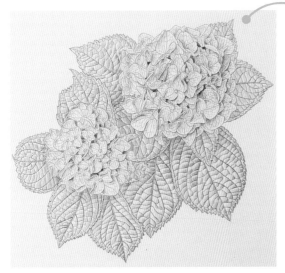

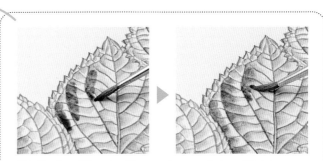

Mix Black and Prussian Blue, and create dark and light colors. Apply the dark color along one side of the lateral veins, and then with a different brush add the light color and blur it in. **TIP**

9 Once all the fine shading has been added to the leaves, add more along the lateral veins. See page 25 on how to add shading. As you get more experienced doing this, your shading technique will greatly improve.

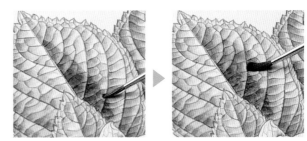

Apply the dark color along one side of the midribs and then, with a different brush, add the light color and blend it in. **TIP**

10 Use the same color as in step 9 to add the largest shading along the midribs.

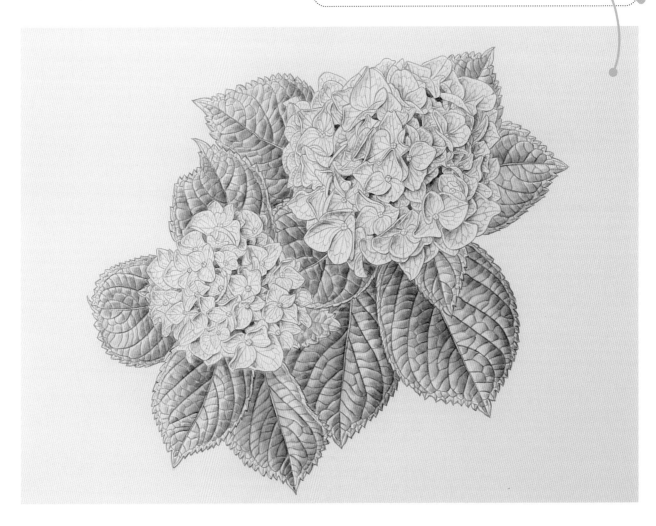

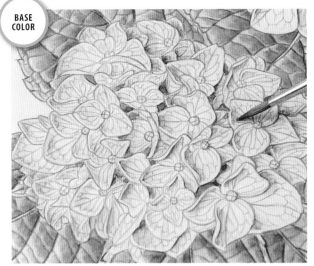

BASE COLOR

11 Mix Cerulean Blue and Cobalt Blue, and color the bottom left inflorescence. Leave the edges uncolored and white to give a sense of thickness to the sepals.

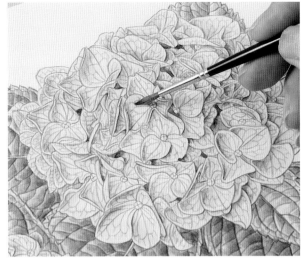

12 Using the same blend as in step 11, color the top right inflorescence too. Lightly color the area near the center of the flower and make it darker toward the edge.

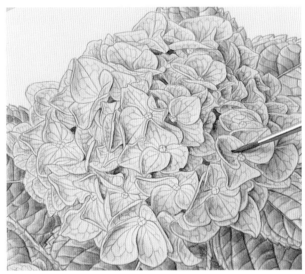

13 Color and layer the shading in the bottom right, while creating an overall rounded appearance.

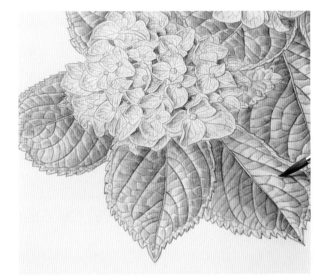

14 Lightly color the entire leaves with Sap Green, while paying attention to the shading.

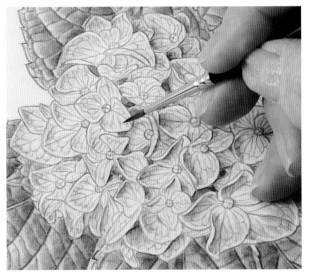

15 Mix a small amount of Cerulean Blue into Cobalt Blue, and color the edges and veins of the sepals.

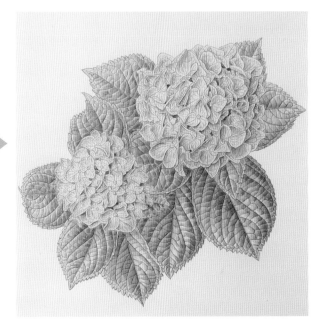

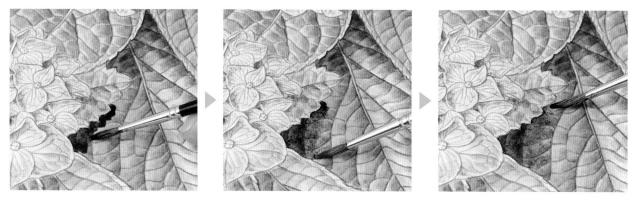

16 Mix Black and Prussian Blue to create a dark color. Then add more Prussian Blue to create a light color. Add shading to the bottom right of the overlapping leaves. Apply the dark color and then, with a different brush, add the light color and blend it in down to the bottom right. Next, use a wet brush to further blend the color.

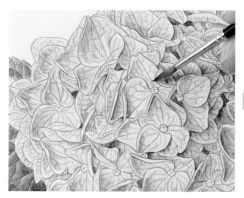

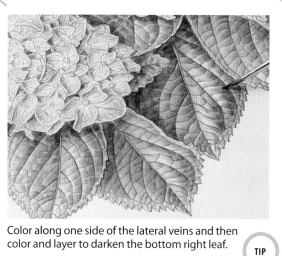

Color along one side of the lateral veins and then color and layer to darken the bottom right leaf.

TIP

17 Color and layer the leaves with Hooker's Green, and then using the color created in step 16, strengthen the shading between the inflorescences and in the bottom right.

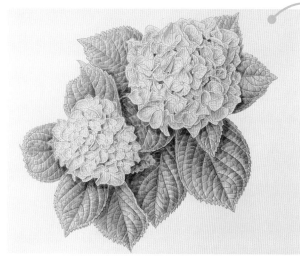

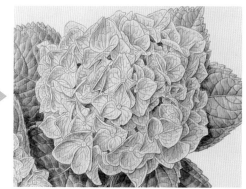

18 Near the center of the top-right inflorescence, color using Opera. Use a dry brush, with the excess water wiped off, lightly color and create a blurred, reddish tint.

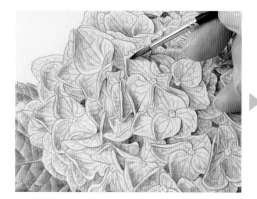

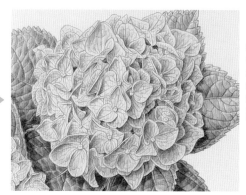

19 Color and layer with Ultramarine Deep along the top-left margin of the sepals of the top-right inflorescence. Add darker shading, aiming to create the deep blue-purple flower color.

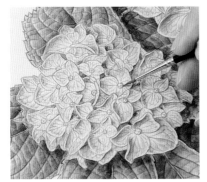

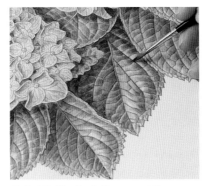

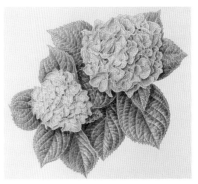

20 To emphasize the sky blue of the sepals of the younger inflorescences in the bottom left, add Manganese Blue Nova, and color the central part of the flowers with Lemon Yellow.

21 Mix Hooker's Green and Deep Yellow, and color and layer along the veins. Firmly layering the color on the leaves will make the beautiful flowers stand out.

22 To create rounder inflorescences, layer the color, emphasizing the bottom-right area, and then adjust the details to complete the work.

THE COMPLETED ARTWORK

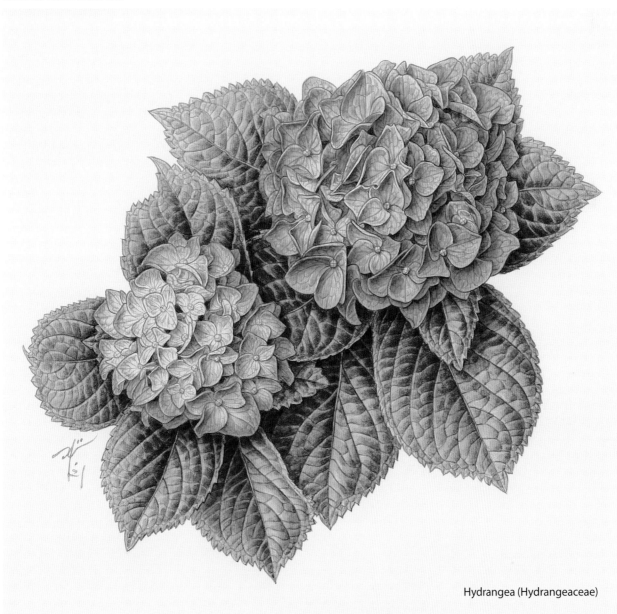

Hydrangea (Hydrangeaceae)

Drawing a Primrose

Primrose come in many varieties, and they're a thrill to draw with their adorably frilly flowers that bloom like roses. To emphasize the unevenness of the leaves, you'll be adding color to a pen drawing. Choose a pen that is water-based and becomes water-resistant when dry. Test it out by drawing on the paper and then applying water after it's dried to be sure it doesn't bleed.

● Deep Yellow
● Opera

● Hooker's Green
● Prussian Blue

Adding Pen to the Sketch

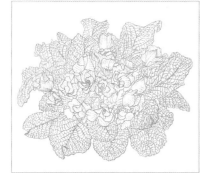

1 Here the sketch in pencil is completed. Some of the outer leaves have been omitted.

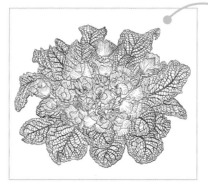

2 Add pen to the sketch using a water-resistant ballpoint pen. Trace the outlines of the leaves and petals.

Use dotted lines for the petals and stippling along the leaf veins for the shading of the leaves.

TIP

Adding Color

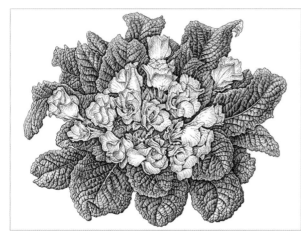

1 Here all the shading has been added in pen. Make the leaves darker and the flowers lighter.

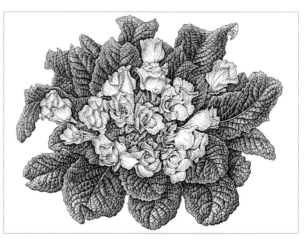

2 Color the shading of the leaves with Prussian Blue.

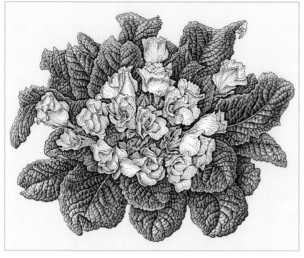

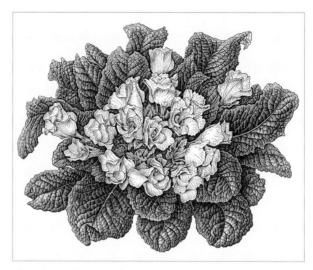

3 Color the petals and the reflective surfaces of the leaves with Deep Yellow.

4 Color and layer the leaves with Hooker's Green, and then add Opera to the petals to complete the work. Use the pen lines as much as possible to make the coloring phase easier.

THE COMPLETED ARTWORK

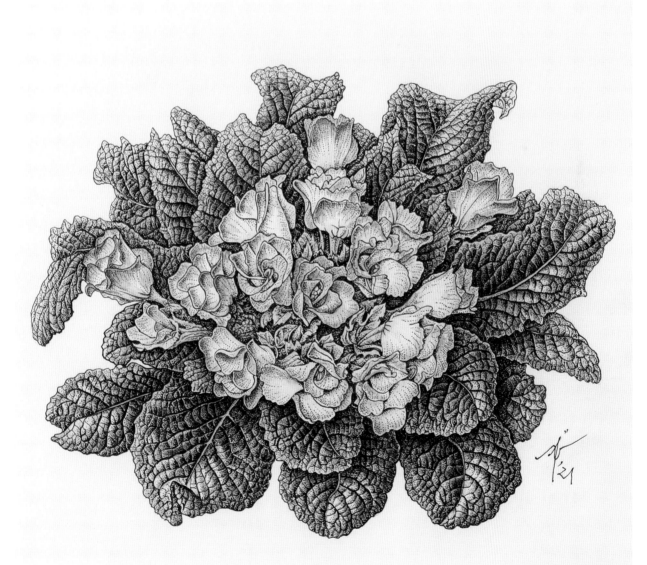

Primrose (Primulaceae)

Drawing Holly

Holly is an evergreen shrub characterized by its spiky leaves and berries that ripen to a bright red in winter. Synonymous with the holiday season, the waxy leaves contrast with the crimson berries.

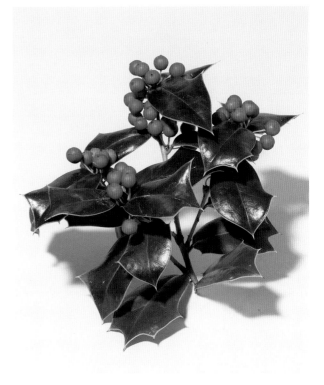

- ○ Deep Yellow
- ● Rose Madder
- ● Burnt Sienna
- ● Sap Green
- ● Hooker's Green
- ● Prussian Blue
- ● Black (Peach Black)

Adding Shading to the Sketch

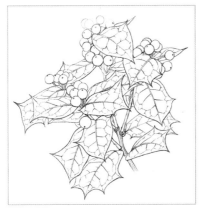

1 Here the sketch is completed. Make a copy of the sketch and add shading to that copy with a pencil.

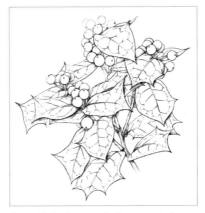

2 Add shading to the bottom right where the leaves overlap.

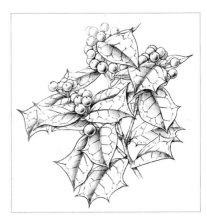

3 Add shading to one side of the midribs on the leaves and to the bottom right of the berries.

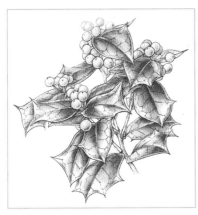

4 Add more shading to the leaf margins and the midribs.

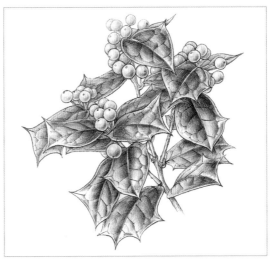

5 Add more shade to the berries and the lateral veins of the leaves to use as reference when adding color.

90

Creating the Sketch

SHADING

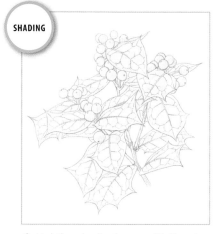

1 Lightly color the leaves with Prussian Blue and the berries with Deep Yellow, leaving the areas that catch the light uncolored.

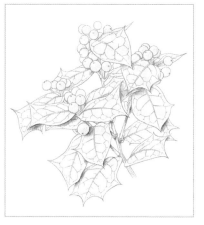

2 Mix Prussian Blue and Black, adding shade to the bottom right where the leaves overlap.

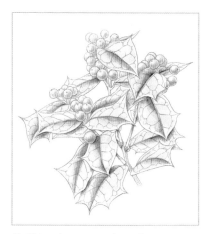

3 Using the same color as in step 2, add shade to one side of the midribs. Use Burnt Sienna for the bottom right of the berries.

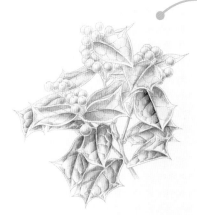

4 Add more shade to the leaf margins and the lateral veins.

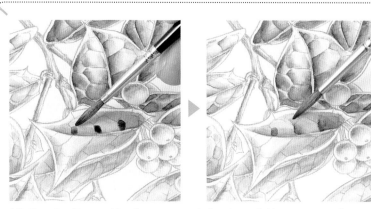

Mix Prussian Blue and Black to create a dark color and dilute Prussian Blue to make a light color. Use the dark color to apply along the lateral veins of the leaves and then, with a different brush, add the light color and blend it in.

TIP

BASE COLOR

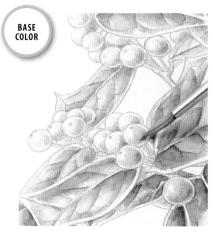

5 Color the berries with Deep Yellow. Leave the parts the light catches uncolored.

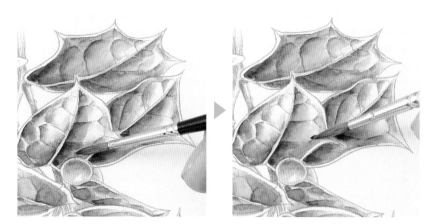

6 Create a dark color with Sap Green and make a yellow-green color by mixing Hooker's Green and Deep Yellow. Add the dark color to the midribs and margins of the leaves and then, with a different brush, add the yellow-green color and blend it in.

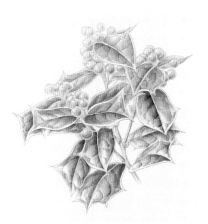

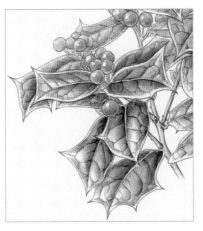

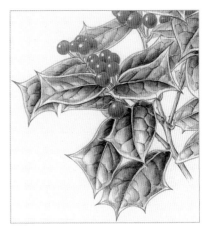

7 Here all the leaves have been colored. Make the leaves in the foreground darker and the ones toward the back lighter.

8 Use Burnt Sienna to make the outlines of the leaves and berries darker, and then add Opera to the dark areas of the leaves and the whole of the berries (except the parts that catch the light).

9 Color and layer the leaves with Hooker's Green, add Deep Yellow to the leaf margins and midribs, and then color the dark areas of the berries with Rose Madder.

THE COMPLETED ARTWORK

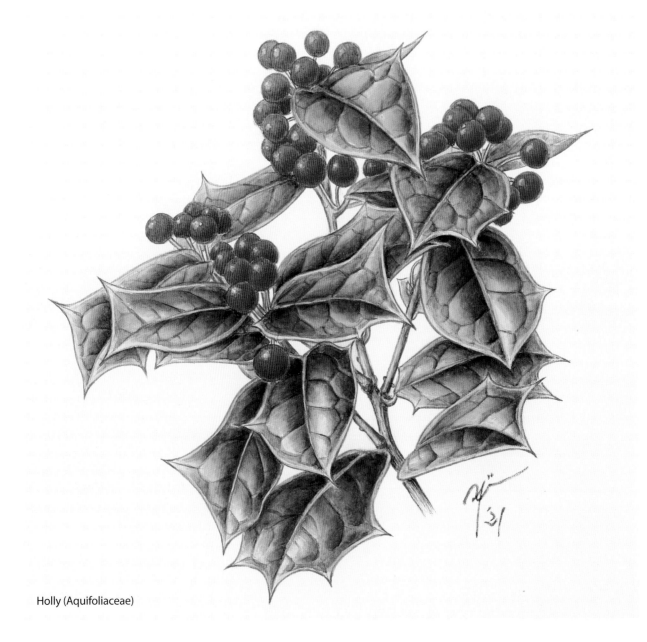

Holly (Aquifoliaceae)

Drawing Kumquats

Kumquats have beautiful evergreen leaves and small tangerine-colored fruit. Rather than drawing the branches as they are, cut the section you need and position it as you wish. Here I placed the younger fruit at the back and showed how they gradually ripen, placing the ripe fruit in the very foreground.

- ⬜ **Lemon Yellow**
- 🟡 **Deep Yellow**
- 🔴 **Opera**
- 🟤 **Burnt Sienna**
- 🟢 **Hooker's Green**
- 🔵 **Prussian Blue**

Adding Pen to the Sketch

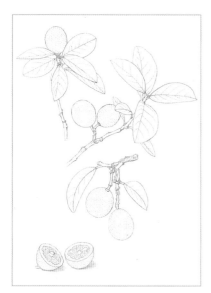

1 Here's the completed sketch. I chose a collage effect for the composition.

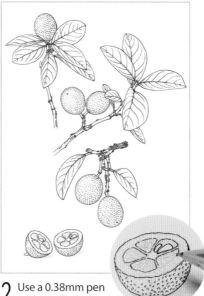

2 Use a 0.38mm pen to draw along the outlines.

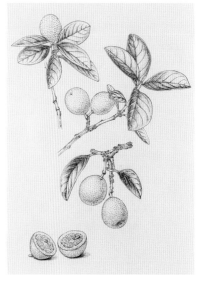

3 Stipple with the pen to add shading.

93

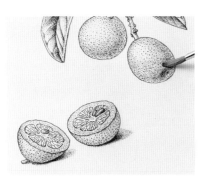

1 Add Lemon Yellow to the skin of the fruit, the cross-sections and branches, leaving the areas that catch the light uncolored.

2 Color the leaves with Prussian Blue. To accentuate the stippling best, apply the paint quickly.

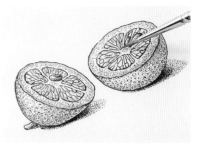

3 Using a size 1 brush, color the grains of the cross-sectioned flesh with Deep Yellow. Color only along one side of the outlines.

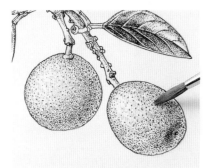

4 Color the skin of the fruit with Deep Yellow. Stipple the fruit in the foreground and do a flat wash for the ones at the back.

5 Color the leaves with Deep Yellow too. Make the leaves in the foreground darker and the ones at the back lighter.

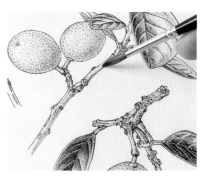

6 Lightly color the branches with Hooker's Green.

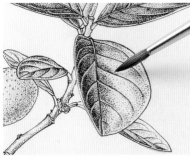

7 Color the leaves with Hooker's Green too.

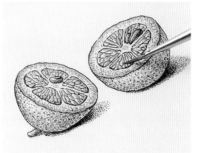

8 Mix Deep Yellow and Opera, and using a size 1 brush, color and layer the flesh of the fruit.

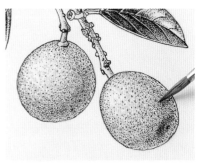

9 Using the same blend as in step 8, color the skin of the fruit. Make the fruit at the back darker than the ones at the front.

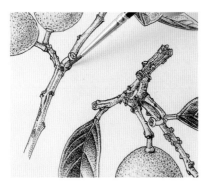

10 Color the parts where the flowers have fallen from the branches with Burnt Sienna.

11 Adjust the shading of the leaves and fruit to complete the work.

THE COMPLETED ARTWORK

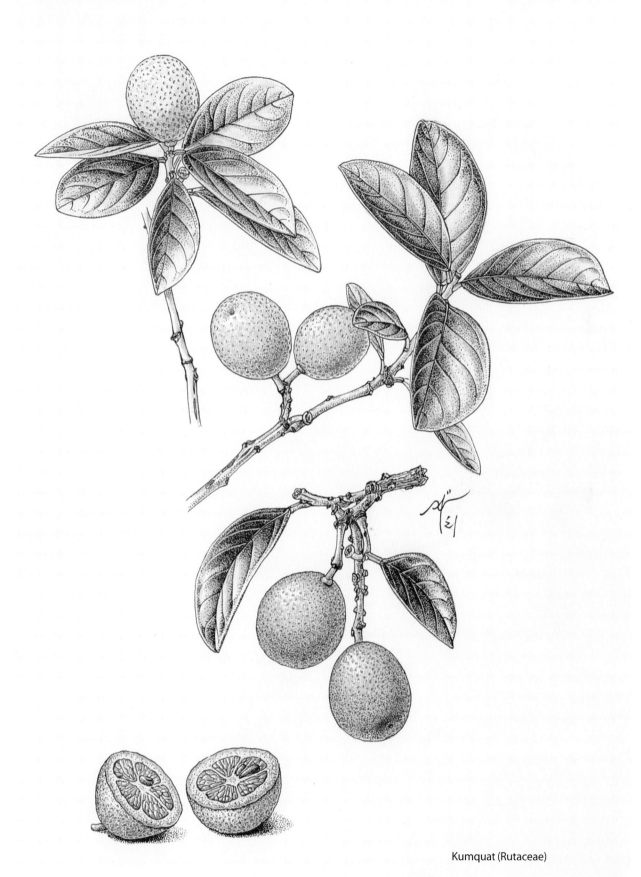

Kumquat (Rutaceae)

Drawing a Red Onion

The red onion is actually a purplish red, a hue that draws many botanical artists. The green sprouts here act as an accent. A more common subject in recent botanical art, shading is added to the sketch using colored pencils, then color is added to capture that appealing deep purplish red.

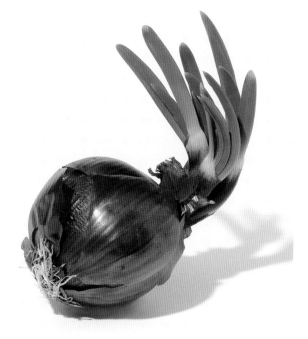

- ● Deep Yellow
- ● Opera
- ● Ultramarine Deep
- ● Hooker's Green

Colored Pencils:
Black; Ultramarine Blue; Dark Purplish-Red; Green

Adding Color to the Sketch

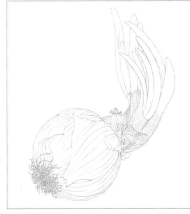

1 Here's the completed sketch.

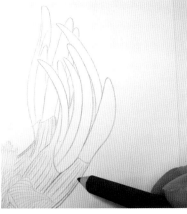

2 Add color to the outlines in the sketch using colored pencils. Draw the extending sprouts with green and the bulb with ultramarine blue.

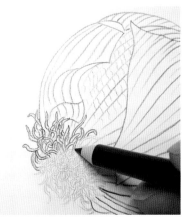

3 Draw the skin of the onion with dark purplish red and the roots with black.

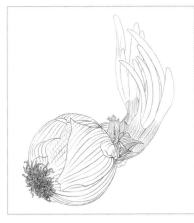

4 Here's the completed line drawing made with colored pencils.

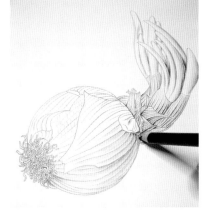

5 Add shading using a black-colored pencil.

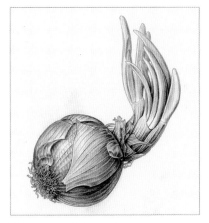

6 Here the shading has been added to the whole subject. Add more shading before adding the color.

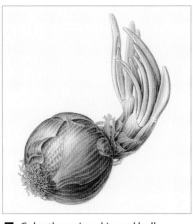

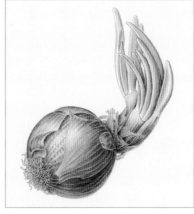

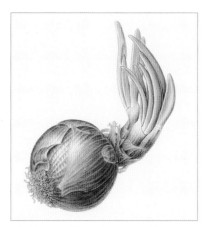

7 Color the onion skin and bulb with Opera.

8 Color the onion skin, bulb and sprouts with Deep Yellow.

9 Color and layer the onion skin and bulb with Ultramarine Deep and use Hooker's Green for the sprouts. Color and layer the skin using Opera to complete the work.

THE COMPLETED ARTWORK

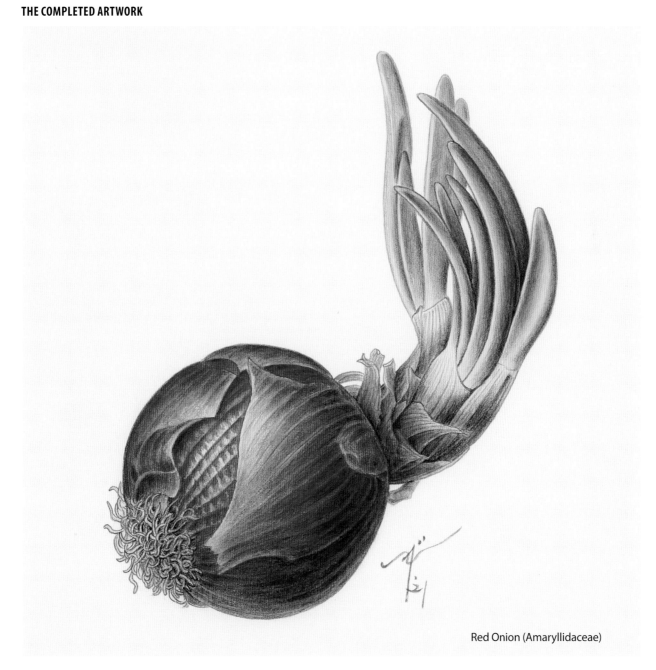

Red Onion (Amaryllidaceae)

Drawing a Succulent

The rosette-shaped leaves of this distinctive succulent spread out from a slender stem to create an impressive flower-like form. This beautiful plant boasts glossy blackish purple leaves. You can easily use your own favorite succulent form instead. These dainty, decorative plants are good practice for capturing the waxy texture of those glossy leaves.

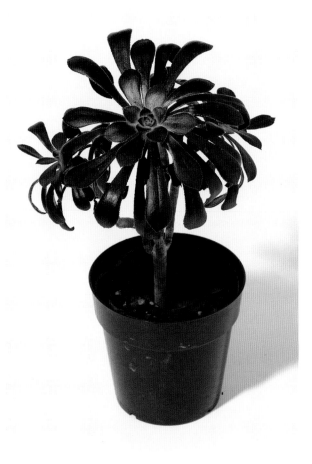

- ◌ Lemon Yellow
- ◍ Opera
- ● Rose Madder
- ◔ Purple (Mineral Violet)
- ◑ Ultramarine Deep
- ◕ Sap Green
- ● Black (Peach Black)

Adding Shading to the Sketch

1 Draw the sketch with a pencil. Be sure to carefully add in the fine serrations of the leaf margins. Once the sketch is complete, make a copy.

2 Add shading with a pencil to the copy. Here, it's been added to the tips of the leaves first.

3 Add shading to emphasize the luster of the leaves.

4 Here the shading has been added to the whole subject. Use this as a reference when adding color.

Creating the Sketch

SHADING

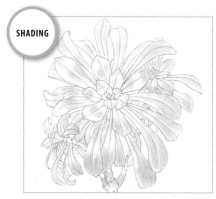

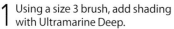

1 Using a size 3 brush, add shading with Ultramarine Deep.

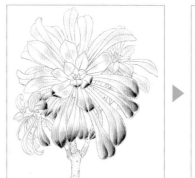

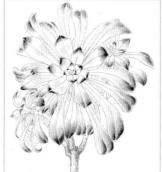

2 Mix Black and Purple, then add shading to the tips of the leaves.

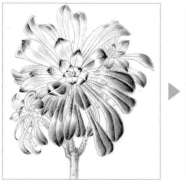

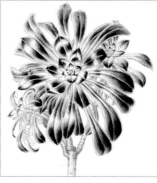

3 Add shading near the centers of the leaves.

BASE COLOR

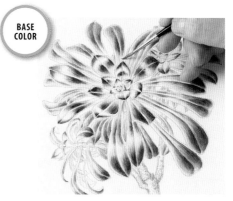

4 Color the central area with Lemon Yellow.

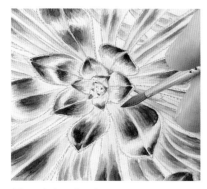

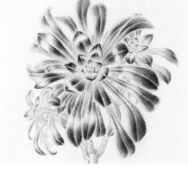

5 Lightly color the central area with Opera.

6 Color and layer with Rose Madder. Draw the lines carefully one by one to create the glossy texture.

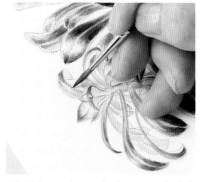

7 Color and layer the leaves to the left and right with Rose Madder.

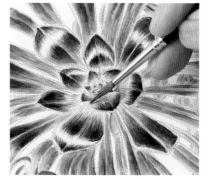

8 Color and layer the central part with Sap Green.

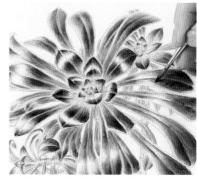

9 Color and layer with Ultramarine Deep to make the shading darker.

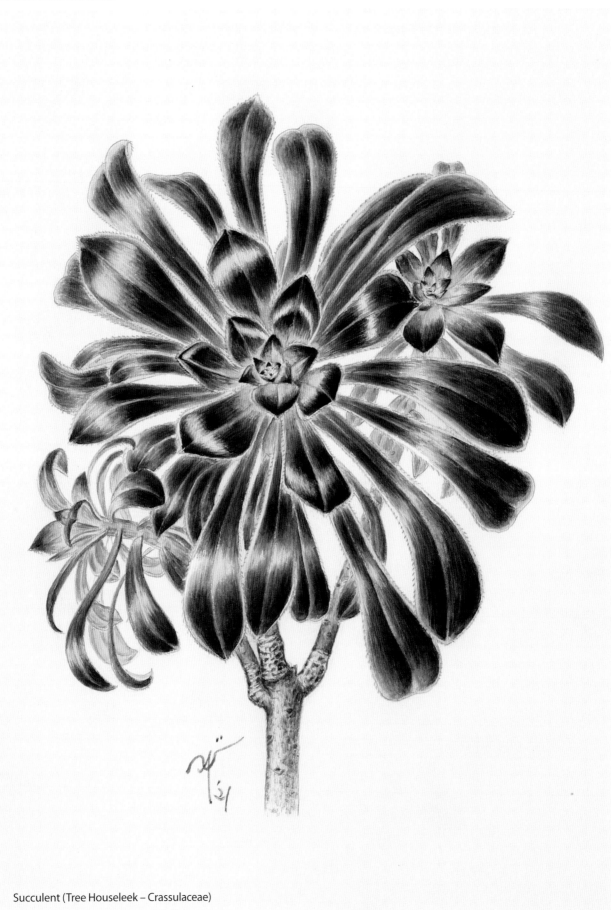

Succulent (Tree Houseleek – Crassulaceae)

Drawing a Panda Plant

The Japanese name for the panda plant is tsukitoji, meaning "moon rabbit ears," because of the shape of the leaves and the fact they're covered in fine white downy hairs. The margins have characteristic brown spots. Draw a combination of opened and unopened leaves, expressing their fluffy texture by using stippling. Or find a fuzzy cactus or another type of succulent to practice drawing instead.

- ⬤ Deep Yellow
- ⬤ Opera
- ⬤ Rose Madder
- ⬤ Purple (Mineral Violet)
- ⬤ Cerulean Blue
- ⬤ Burnt Sienna
- ⬤ Sap Green
- ⬤ Prussian Blue
- ⬤ Black (Peach Black)

Creating the Sketch

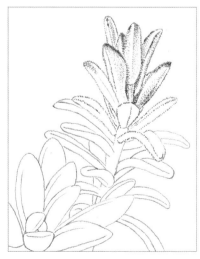

1 Draw the sketch using a pencil. Using stippling for the fine downy hairs allows you to suggest the fluffy texture.

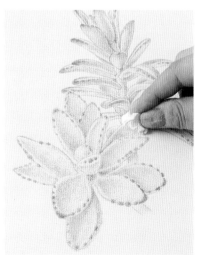

2 When the sketch is complete, lightly press a kneaded eraser to remove excess graphite dust and make the lines fainter.

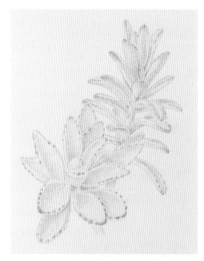

3 Make the back fainter than the front to create perspective. Once the sketch is ready, add color.

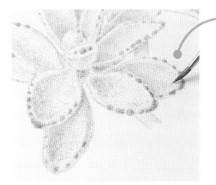

Before adding color, adjust the amount of paint loaded on the brush using tissue paper.

TIP

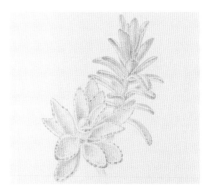

1 Using a size 3 brush, color with Deep Yellow. Use stippling to express the downy hairs.

2 Here's the stippling finished using Deep Yellow.

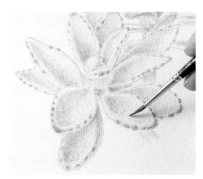

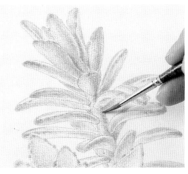

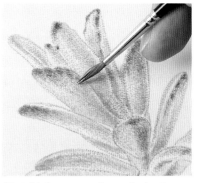

3 Next, color using Cerulean Blue.

4 Color the stem with Cerulean Blue too.

5 Mix Opera and Deep Yellow into Burnt Sienna and color the spots.

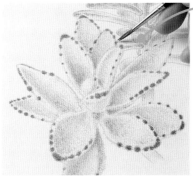

The paint is loaded right down to the base of the bristles, so you can continue coloring without having to add much paint partway through.

TIP

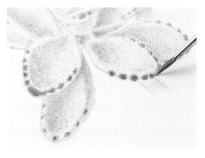

6 Add spots to the whole subject.

7 Add the same color to the back leaves of the plant too.

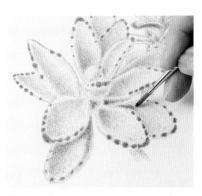

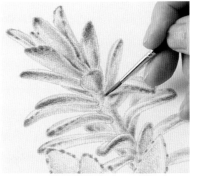

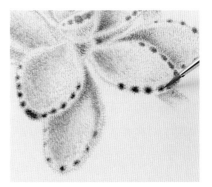

8 Mix Black and Prussian Blue and use that color to add shading.

9 Add shading to the back leaves and stem of the plant, but as they're far in the background, make them lighter.

10 Mix Purple, Rose Madder and Black, and then using a size 1 brush, add dots to the center of the spots.

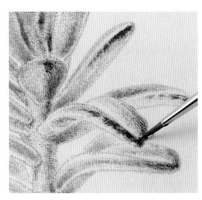

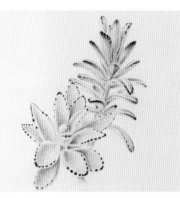

11 Mix Deep Yellow into Rose Madder and color the tips of the leaves.

12 Add a small amount of Sap Green to the center part of the leaves.

13 Add your signature to complete the work.

THE COMPLETED ARTWORK

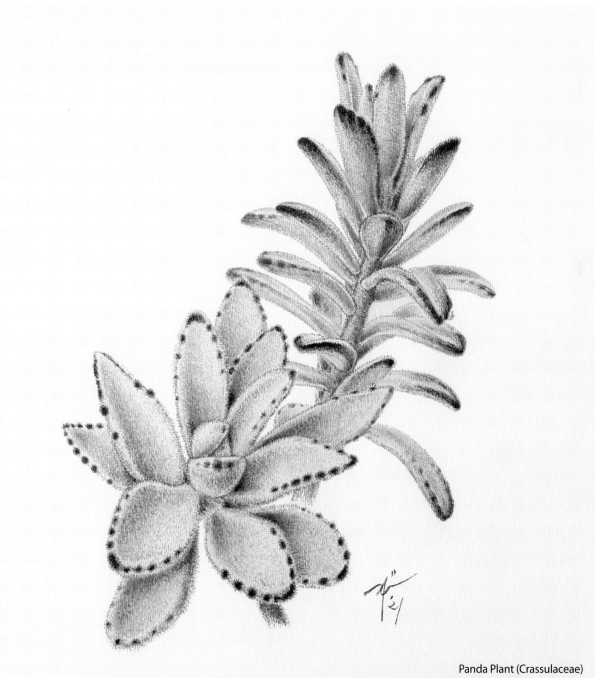

Panda Plant (Crassulaceae)

Drawing a Walnut

Now it's time to draw a hard-shelled English walnut. Shading is added with colored pencils before adding color, so as to capture the texture of the rigid shell. In order to capture all the fine details, it's drawn at a magnification four times its original size.

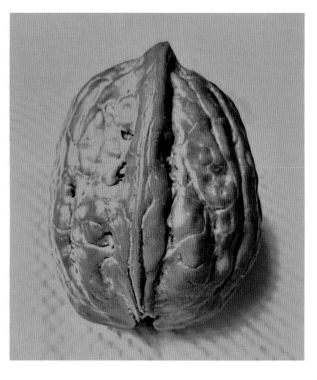

⬤ **Deep Yellow** ⬤ **Burnt Sienna**

Colored Pencils:
Black; Dark Brown; Reddish Brown

<div style="background:gray">**Adding Color to the Sketch**</div>

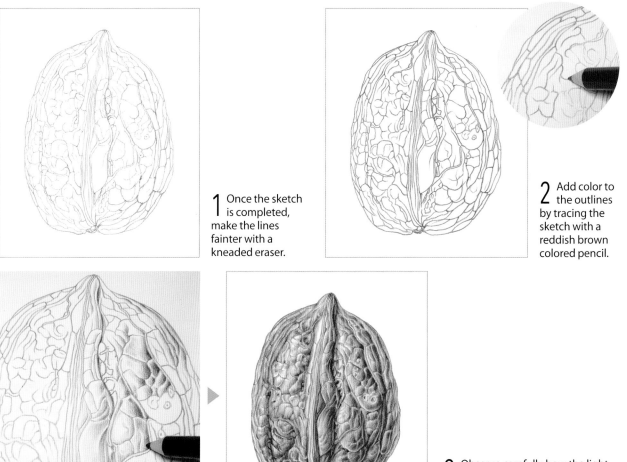

1 Once the sketch is completed, make the lines fainter with a kneaded eraser.

2 Add color to the outlines by tracing the sketch with a reddish brown colored pencil.

3 Observe carefully how the light catches the surface and use a black pencil to add shading to the parts that have shade. Leave the parts that catch the light uncolored.

104

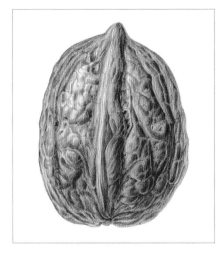

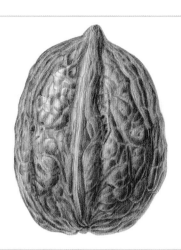

4 Use a dark brown pencil to add more shading.

5 Add color to the lustrous surface areas using Deep Yellow. Add more shading with Burnt Sienna to complete the work.

THE COMPLETED ARTWORK

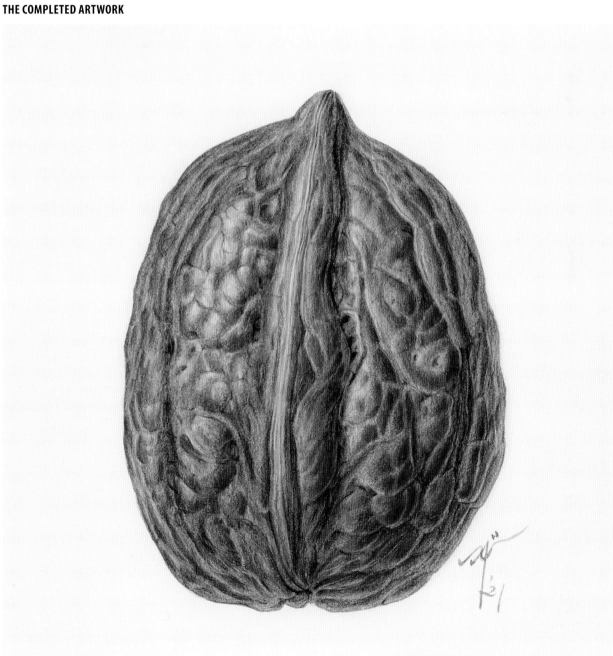

English Walnut (Juglans regia/Juglandaceae)

Drawing a Pinecone

The beautiful shape of a pinecone is formed from scales arranged in a double spiral. Collecting the cones is only the first step. Find a form that interests or inspires you. Thoroughly add shading using colored pencils and then add the layers of color. In order to depict all the fine details, it's drawn at a three times magnification.

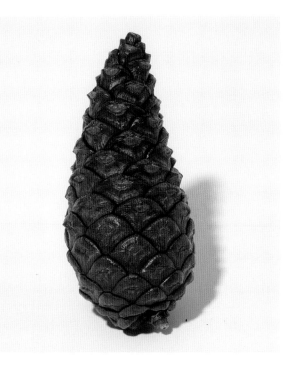

● **Ultramarine Deep** ● **Burnt Sienna**

Colored Pencils:
Black; Light Purple; Reddish Brown

Creating the Sketch

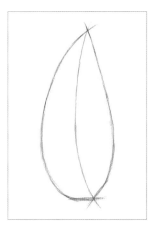

1 Start by drawing the center line and the outlines on the left and right.

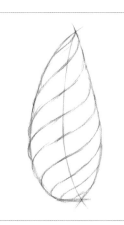

2 Draw a row of scales rising to the right.

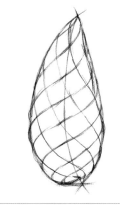

3 Draw a row of scales rising to the left.

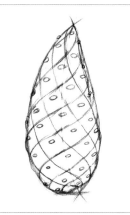

4 Draw the position of the spiky parts at the tips of the scales.

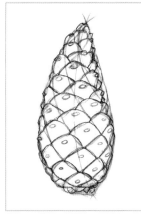

5 Draw the rough outline of each of the scales.

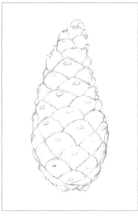

6 Erase the excess lines, use a kneaded eraser to make the overall sketch fainter and then draw in the details.

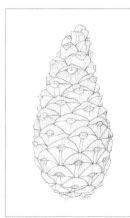

7 Once the sketch is completed, make the lines fainter with a kneaded eraser.

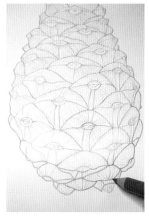

8 Add color to the outlines by tracing the sketch with a light purple pencil.

Adding Shading and Color

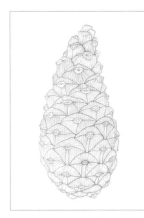
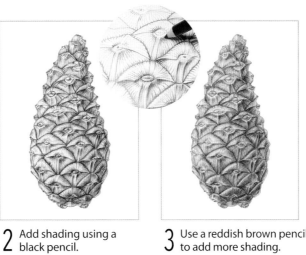

1 Here color has been added to all the outlines using light purple.

2 Add shading using a black pencil.

3 Use a reddish brown pencil to add more shading.

4 Color the darker surface areas with Ultramarine Deep, then apply Burnt Sienna to complete the work.

THE COMPLETED ARTWORK

Pinecone of a Japanese Black Pine (Pinaceae)

Drawing Tulips

The beauty of tulips lies in the simple forms of the flowers and leaves. The buds and the flowers in bloom are both attractive, so here I created a composition including both. Adding shading with colored pencils before layering on the color means that the glossy deep hues of the blooms can be captured. If you add shading using watercolors and the color smudges when you add the base color, try using this technique.

● Lemon Yellow
● Deep Yellow
● Opera

● Hooker's Green
● Prussian Blue

Colored Pencils:
Black; Indigo; Celadon; Light Red; Ocher; Dark Brown

Creating the Sketch

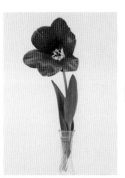 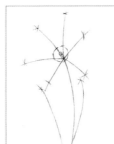

1 Start by drawing the approximate positions of the center, stem and petals of the flower in full bloom, and then make a rough sketch, determining the size of the petals and the position of the leaves.

2 Draw the approximate positions of the stem and leaves for the flower coming into bloom, and then make a rough sketch, determining the size of the bud and length of the leaves.

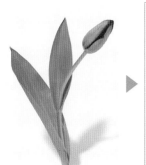 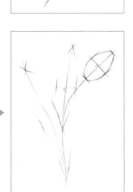

3 Draw the approximate positions of the stem and leaves for the flower still in bud, and then make a rough sketch, determining the size of the bud and length of the leaves.

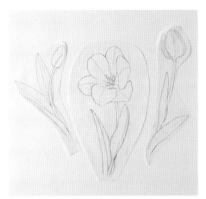

4 To help with planning the composition, make copies of the sketches and cut them out (see page 50).

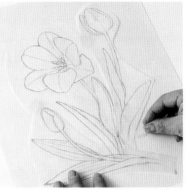

5 Arrange the cut-out copies on paper and once you've decided the composition, fix them in place with masking tape.

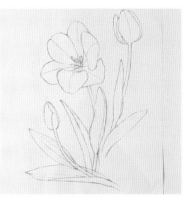

6 Make a copy of the arrangement in step 5 and use a 4B pencil to coat the back of that copy, covering the shapes of the motifs.

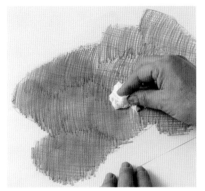

7 Once you've changed the direction of the pencil line and sufficiently coated the paper, gently rub with tissue paper to spread the graphite dust evenly.

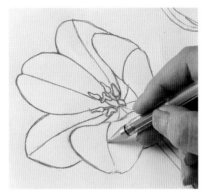

8 Lay the copy face-up on the paper and trace the lines of the sketch. Use a gold pen so that it's easy to see the lines you've traced.

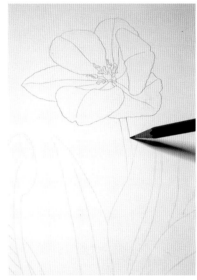

9 After the sketch is traced, finish with a pencil to create a detailed line drawing.

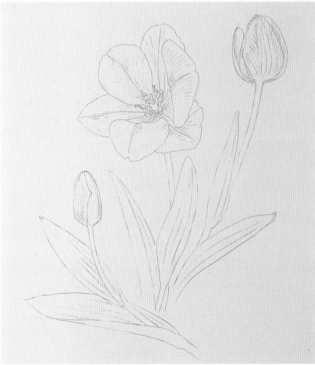

10 Here's the completed sketch.

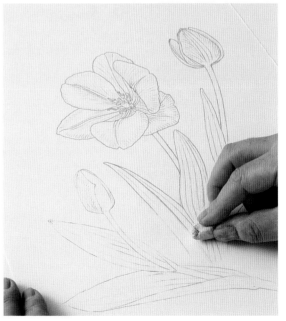

11 Before adding color, remove the excess lines with a kneaded eraser and make the lines fainter.

1 Add color to the outlines of the leaves with a celadon-colored pencil.

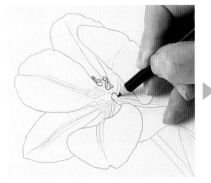

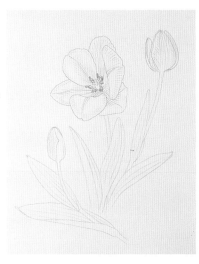

2 Draw the petals in light red, the stamen anthers in black, and the pistils in ocher.

3 Add shading to the base of the leaf using a black pencil.

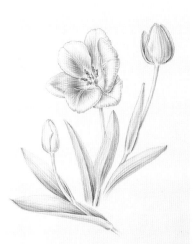

4 Add shading to the tips of the leaves, the stems and the petals where they overlap using black, and add more shading to the petals using dark brown.

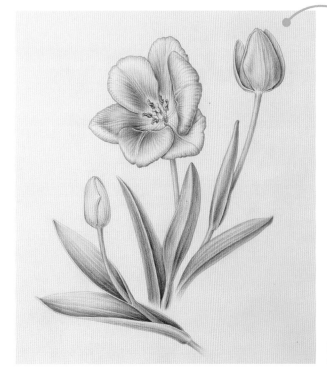

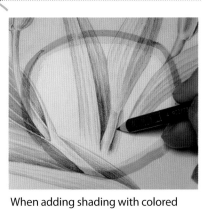

When adding shading with colored pencils, if you cut a hole in a sheet of transparent plastic and place it over the paper, you can avoid smudging.

TIP

5 Here, the shading is completed by adding indigo to the leaves.

Adding Color

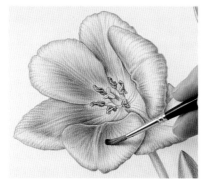

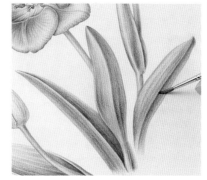

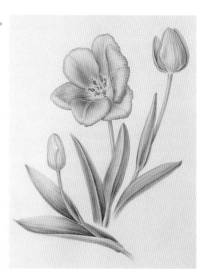

1 Mix a small amount of Deep Yellow into Lemon Yellow, and color the petals and stems. The paint won't stay well on areas that have colored pencil, so color and layer several times.

2 Lightly color the entire leaves with Prussian Blue, and then color along the leaf veins using Hooker's Green.

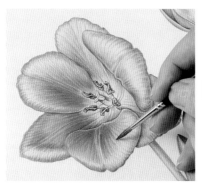

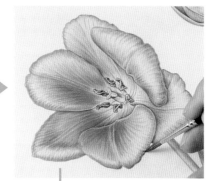

Carefully color the edges of the petals too, following along the flower veins. Use Lemon Yellow on the brighter areas.

Color along the flower veins with Deep Yellow.

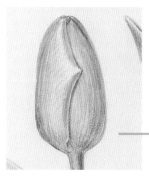

Color the areas in shade on the right-hand flower.

Color along the flower veins of the bottom-left bud too.

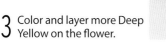

3 Color and layer more Deep Yellow on the flower.

Mix Lemon Yellow and Hooker's Green, then color the stems.

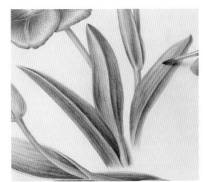

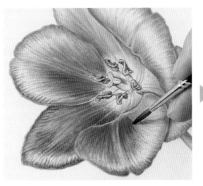

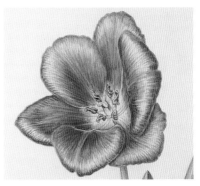

4 Mix Lemon Yellow and Hooker's Green, and color along the leaf veins.

5 Color along the flower veins with Opera. Leave the yellow areas at the base of the flower uncolored.

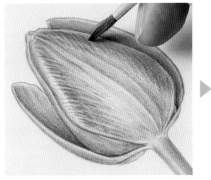

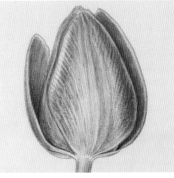

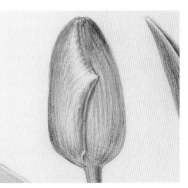

6 Color along the flower veins of the right-hand flower with Opera. Leave the parts where the light catches or that are pale red uncolored.

7 Color the bottom-left bud with Opera. Be careful, making sure not to apply too much.

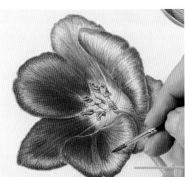

Color and layer along the flower veins with Opera.

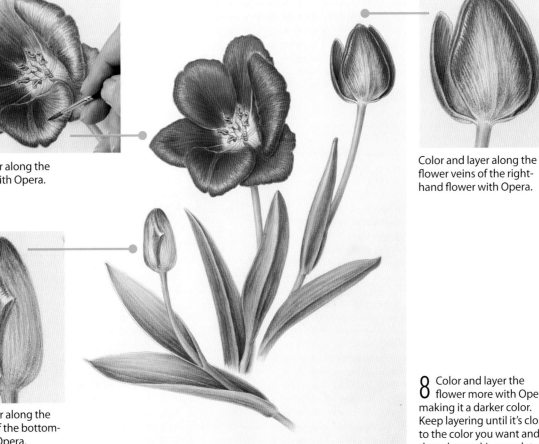

Color and layer along the flower veins of the bottom-left bud with Opera.

Color and layer along the flower veins of the right-hand flower with Opera.

8 Color and layer the flower more with Opera, making it a darker color. Keep layering until it's close to the color you want and then the work's complete.

THE COMPLETED ARTWORK

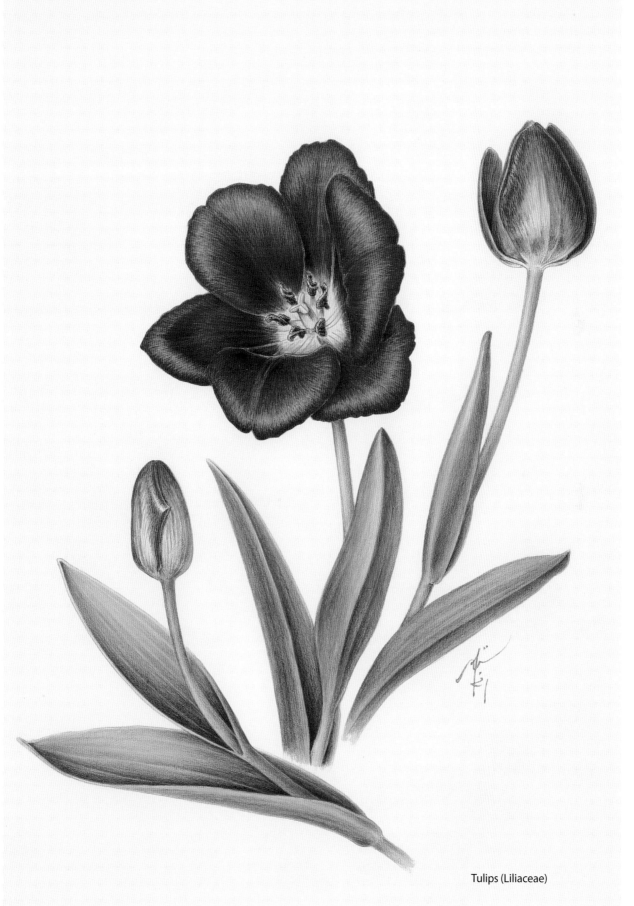

Tulips (Liliaceae)

Drawing Pansies

Pansies are striking with their large, gorgeous flowers. In this composition, pair attractive pansies in various colors with lovely violets.

○ White (Titanium White)
Lemon Yellow
Deep Yellow

● Opera
● Rose Madder
● Purple (Mineral Violet)

● Ultramarine Deep
● Burnt Sienna
● Yellow Deep

● Prussian Blue
● Black (Peach Black)

Adding Shading with Colored Pencils

① ② ③ ④ ⑤ ⑥ ⑦ ⑧ ⑨ ⑩

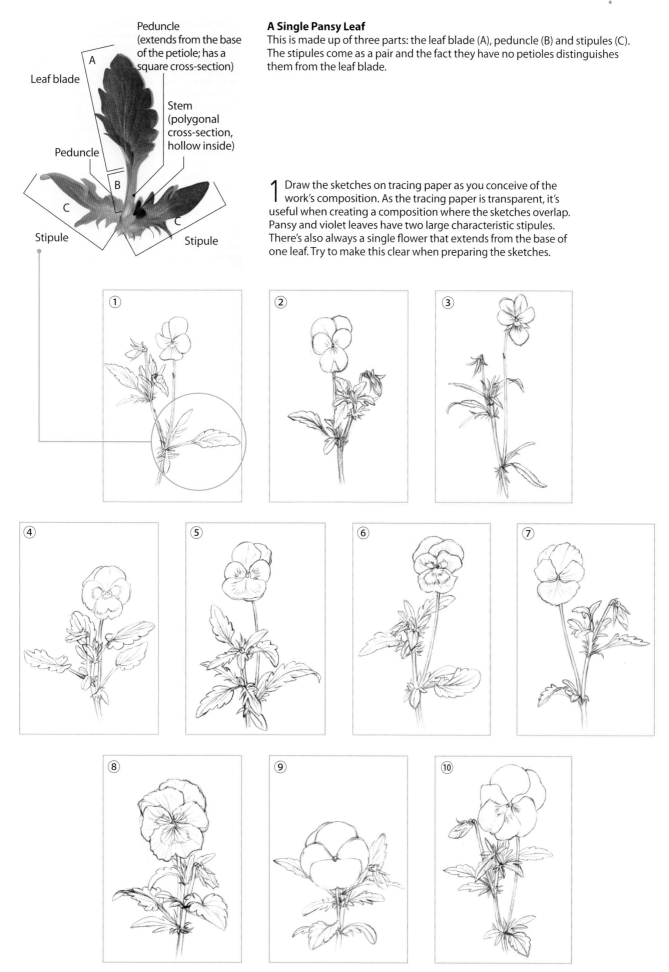

Peduncle (extends from the base of the petiole; has a square cross-section)

Leaf blade

A

Stem (polygonal cross-section, hollow inside)

Peduncle

B

C

C

Stipule

Stipule

A Single Pansy Leaf
This is made up of three parts: the leaf blade (A), peduncle (B) and stipules (C). The stipules come as a pair and the fact they have no petioles distinguishes them from the leaf blade.

1 Draw the sketches on tracing paper as you conceive of the work's composition. As the tracing paper is transparent, it's useful when creating a composition where the sketches overlap. Pansy and violet leaves have two large characteristic stipules. There's also always a single flower that extends from the base of one leaf. Try to make this clear when preparing the sketches.

① ② ③ ④ ⑤ ⑥ ⑦ ⑧ ⑨ ⑩

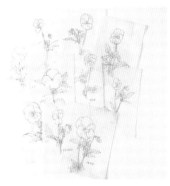

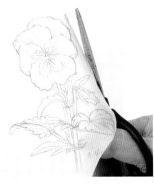

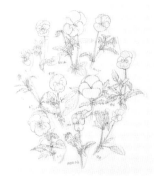

2 Here all the pansies have been drawn on tracing paper.

3 Cut around the approximate shape of the sketches.

4 Here all the sketches have been cut out and arranged.

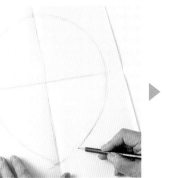

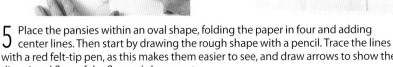

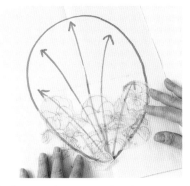

5 Place the pansies within an oval shape, folding the paper in four and adding center lines. Then start by drawing the rough shape with a pencil. Trace the lines with a red felt-tip pen, as this makes them easier to see, and draw arrows to show the directional flow of the flowers' placements.

6 Arrange the cut-out sketches on the paper and think about the composition. Split them into three rows going from front to center to back and place a large flower at the front.

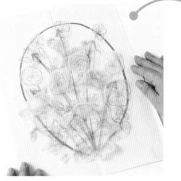

TIP

Think about the balance of the colors and shapes of the actual pansies and try out different compositions, changing where the sketches are placed. It's fine to reverse the sketches too.

7 Here the composition has been decided.

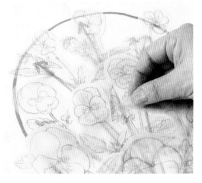

8 Attach the sketches together with masking tape to keep the final placement from shifting.

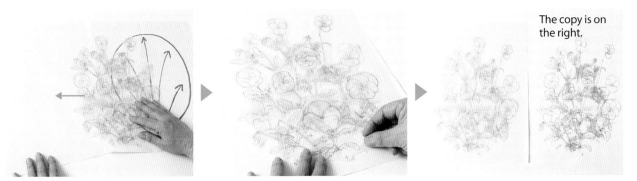

The copy is on the right.

9 Move the sketch to another piece of paper and attach it with tape, then make a copy.

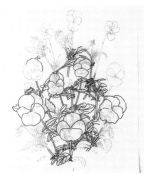

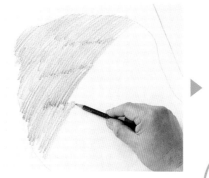

10 Use a black pen to make the fainter parts of the sketch clearer and more distinctive.

11 Use a 4B pencil to coat the back of the tracing paper in preparation for tracing.

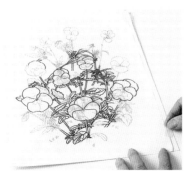

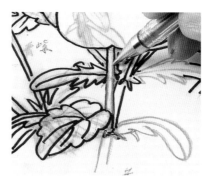

12 Lay the copy face-up on the paper and tape it down so it doesn't slip.

13 Trace the lines of the sketch using a gold pen (a color other than black is easier to see).

Once you've changed the direction of the pencil line and sufficiently coated the paper, gently rub with tissue paper to spread the graphite dust evenly.

TIP

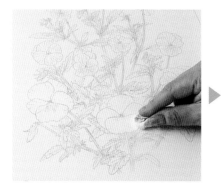

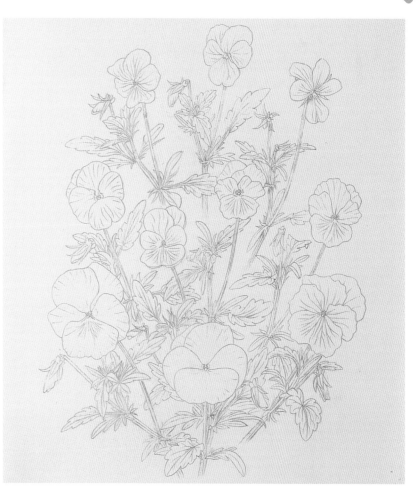

14 Using the traced lines as a base, complete a detailed sketch, while referring to the sketches and actual flowers. Before adding color, make the sketch lines fainter with a kneaded eraser. Adding emphasis to the line drawing will act as a guide for where to emphasize color too. Add the emphasis gradually to the line drawing.

1 Color the outlines of the stems and leaves with Sap Green.

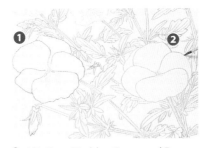

2 Mix Rose Madder, Opera and Deep Yellow, and color the outlines of the flowers in the front row ❶. Draw the flowers in the center front row ❷ using Deep Yellow.

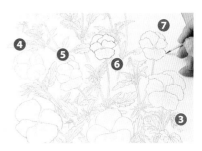

3 Mix and draw with Opera and Purple for the front row ❸, Lemon Yellow and White for the middle row ❹, Ultramarine Deep and Purple for ❺, Rose Madder and Purple for ❻ and Opera and Deep Yellow for ❼.

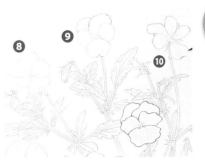

4 Mix and use Ultramarine Deep and Purple for the back row ❽ and Opera and Purple for ❾ and ❿ leaving the white parts of the petals uncolored.

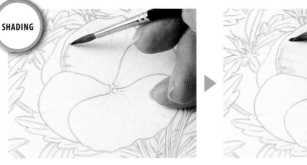

SHADING

5 Add shading to the flowers. Mix Ultramarine Deep and Purple and paint along the flower veins. Then with a different brush, add a lighter color and blend it in. When doing this, leave the edges of the petals white to suggest their thickness.

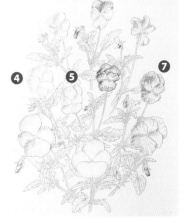

6 Using the color in step 5, add shading to all the flowers. Use Ultramarine Deep and Black for the center rows ❹ ❺ and Rose Madder and Purple for ❼. Layer a number of times to create a three-dimensional effect.

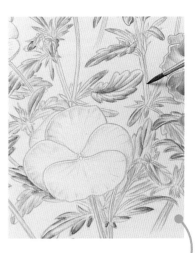

7 For the leaves, use a dark color (Prussian Blue and Black) and a light color (only Prussian Blue), and add shading to one side of the stems using Burnt Sienna.

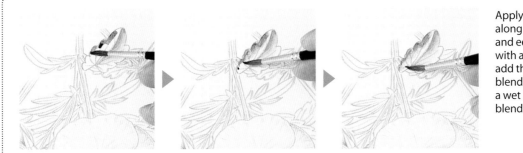

Apply the dark color along the leaf veins and edges, and then, with a different brush, add the light color and blend it in. Next, use a wet brush to further blend the color.

TIP

 BASE COLOR

8 Color and layer each flower with its intrinsic color to add the finishing touches. Work round in rotation from ❶ – ❿ (1st color) and ❶ – ❿ (2nd color), without smudging or rubbing the color underneath. By doing this, you don't have to wait for the paint to dry.

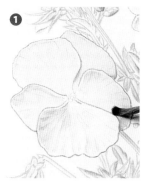

Color with Lemon Yellow.

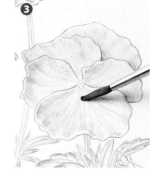

Color with a slightly darker Lemon Yellow.

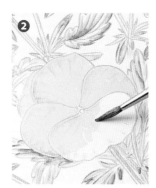

Color with Opera.

Mix White and Lemon Yellow and use that to color.

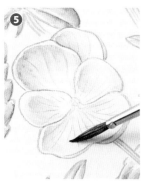

Color with Ultramarine Deep. Make it lighter as you move toward the center.

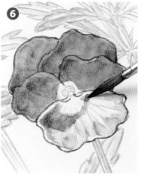

Color with Opera. Leave the white and yellow parts in the center uncolored.

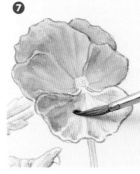

Color with slightly dark Deep Yellow. Then color and layer with Opera.

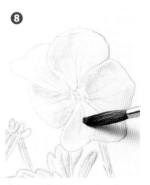

Color with Ultramarine Deep.

Color with Opera.

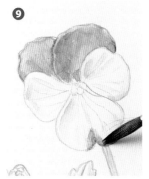

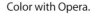

Color with Opera.

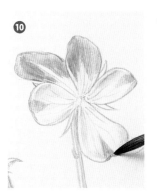

Here the first base color for each of the flowers has been added. After this, the colors will be layered, until the real color has been achieved.

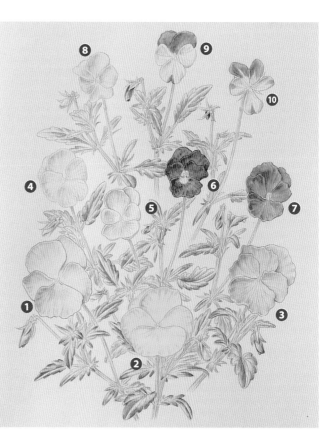

9 Color the leaves with Sap Green. Layer the second and third colors for the leaves too, making them darker. Make the lower leaves darker than the upper ones to give the picture a sense of balance and stability.

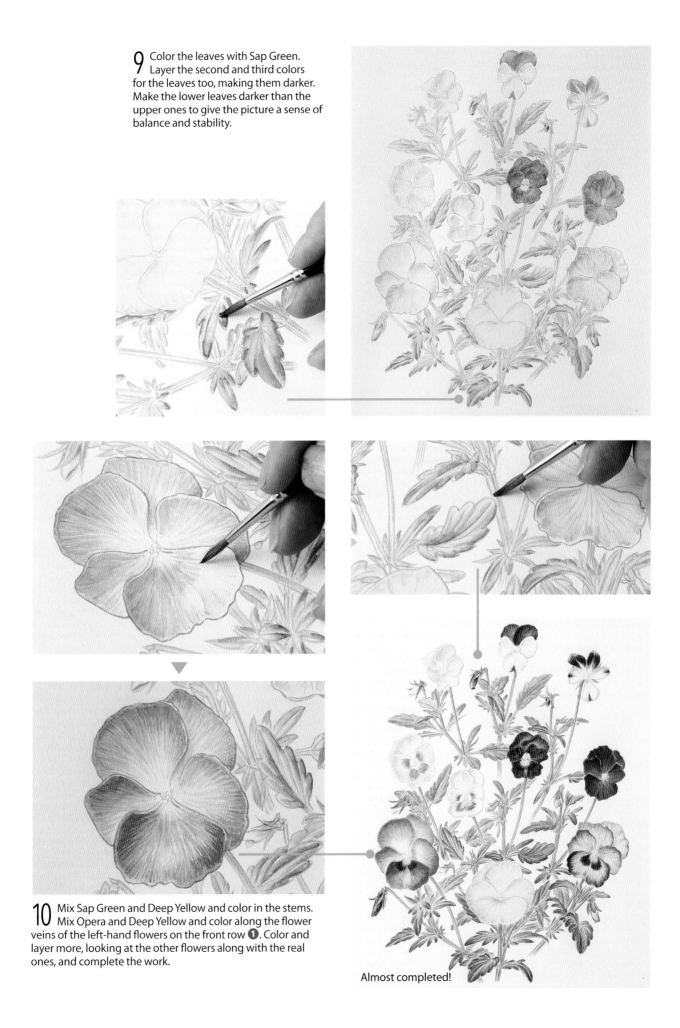

10 Mix Sap Green and Deep Yellow and color in the stems. Mix Opera and Deep Yellow and color along the flower veins of the left-hand flowers on the front row ❶. Color and layer more, looking at the other flowers along with the real ones, and complete the work.

Almost completed!

THE COMPLETED ARTWORK

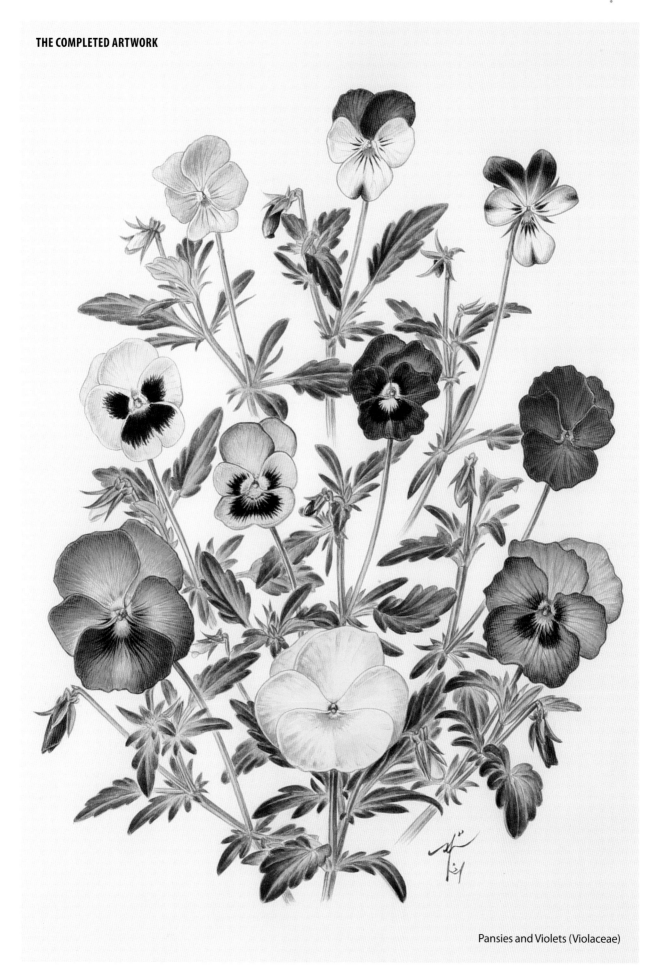

Pansies and Violets (Violaceae)

Drawing Wildflowers

The wealth of wildflowers, such as dandelions, clover and goldenrod, provide an endless supply of subjects for the botanical artists.

Lemon Yellow
Deep Yellow
● **Opera**
● **Cobalt Blue**
● **Sap Green**

※ **Only the colors used on page 124 are shown.**

Think About the Composition

① Chinese violet cress

② Philadelphia fleabane

③ Common wheatgrass

④ Japanese knotweed

⑤ Shepherd's purse

⑥ Long-headed poppy

⑦ Long-headed poppy

⑧ Long-headed poppy

⑨ Long-headed poppy

⑩ Common vetch

⑪ Common sowthistle

⑫ Common dandelion

⑬ Common dandelion

⑭ Common dandelion

⑮ Common dandelion puffball

⑯ Red deadnettle

⑰ Chervil larkspur

⑱ Henbit deadnettle

⑲ White clover

⑳ Red clover

1 Draw all the wildflower sketches on tracing paper as you consider the work's composition. The tracing paper is transparent, making it useful when creating a composition where the sketches overlap.

2 Cut the sketches to the approximate shape of the flowers.

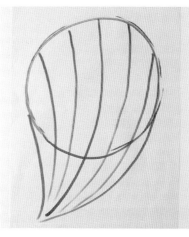

3 To arrange the wildflowers as if they're in a bouquet, draw guide lines on the paper with a red felt-tip pen.

4 Arrange the sketches on the paper, starting from the bottom, moving upward and outward from there.

5 In order to keep the layout in place, attach the sketches together with masking tape. Then move the sketches to another piece of paper.

6 Attach the sketch to the paper with masking tape and copy it.

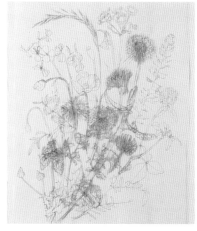

7 Here is the copied sketch. Use this as a base to transfer the sketch to the main paper.

8 Use a 4B pencil to coat the back of the copy and then gently rub with tissue paper to prepare it for tracing.

9 Lay the copy face-up on the paper and fix it in place with tape. Trace the lines of the sketch using a gold pen.

10 Using the traced lines as a base, draw a detailed sketch with either a pencil or mechanical pencil, while referring to the sketches and actual flowers.

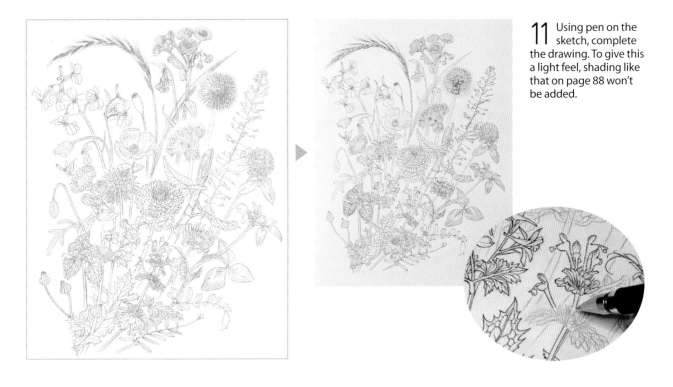

11 Using pen on the sketch, complete the drawing. To give this a light feel, shading like that on page 88 won't be added.

Think About the Composition

※ Color lightly to give a sense of delicate wildflowers.

1 Color the stem and leaves of the common vetch⑩ with Sap Green and the flowers with Opera.

2 Color the stem and leaves of the henbit deadnettle ⑱ with Sap Green, and the flowers with Opera.

3 Color the red deadnettle ⑯ with Sap Green and Opera.

4 Color the stem and leaves of the chervil larkspur ⑰ with Sap Green, and the flowers with a mix of Cobalt Blue and Opera.

5 Color the flowers of the common sowthistle ⑪ with Lemon Yellow and Deep Yellow, and the bud with Sap Green.

6 Color the Japanese knotweed ④ with Sap Green and Opera, and continue coloring the other wildflowers while looking at the real ones, to complete the work.

THE COMPLETED ARTWORK

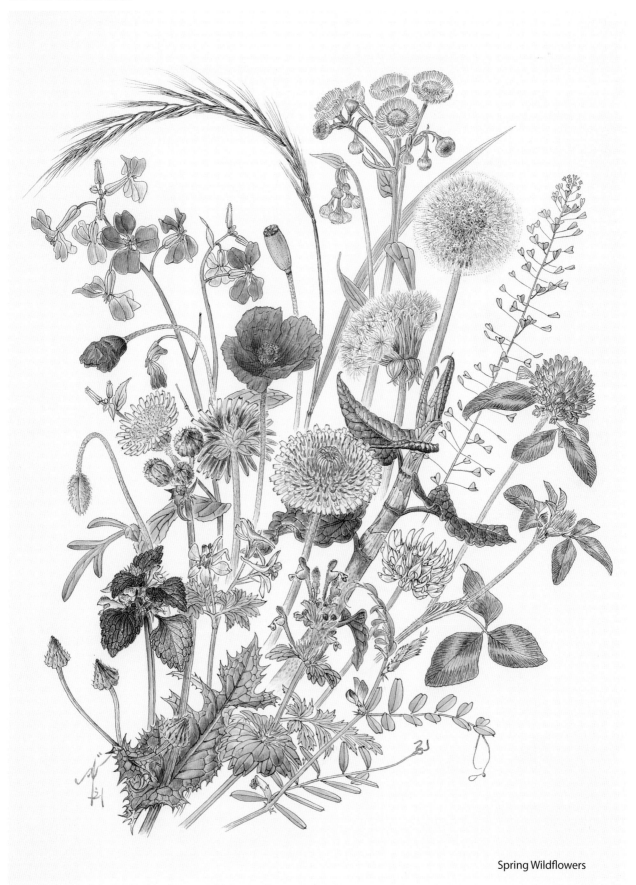

Spring Wildflowers

Framing Your Artworks

The frame acts as a complement to the artwork, making it stand out all the more. Balance, color, proportion and size all come into play, just as they did while you were laboring over the piece you now want to perfectly and lovingly frame!

Choosing a Frame and Matte

With botanical art, as it's usually a single image with no background, it's better to have a neat, undecorated frame that won't detract from the simplicity and formal integrity of the central image. A matte should be placed between the artwork and the frame to protect it. The width should be at least 2.75 inches (7 cm) so the overall piece doesn't feel cramped. A plain, cream-colored matte is a safe choice, but depending on the work, a decorative option with ruled lines or gold on the oblique angles of the board's window can also be suitable.

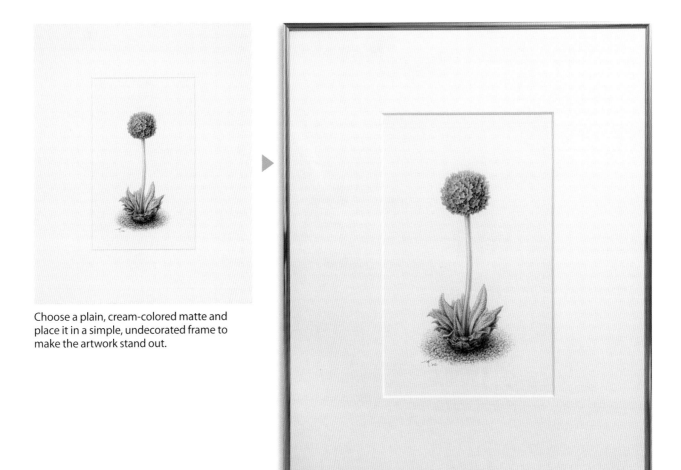

Choose a plain, cream-colored matte and place it in a simple, undecorated frame to make the artwork stand out.

The Botanical Art Competition

The Botanical Art Competition, sponsored by the National Museum of Nature and Science, has been held annually since 1984. There are three divisions: elementary school students, junior and high school students and the general public. Before the creation and inception of the award series, there was no other competition of this kind sponsored by a botanical arts organization.

It has now become a gateway to success for botanical artists, with many who have won awards actively working as artists. It's also a great gallery of ideas to see what other botanical artists are producing.

Japanese Red Pine (Pinaceae): Here flowering branches and cones have been painted on a red pine board.

The Japanese Association of Botanical Illustration

The Japanese Association of Botanical Illustration (www.art-hana.com), established in 1991, is a nationwide organization of botanical art enthusiasts. There are no qualifications for membership and the author has been a member since participating in the first general meeting as one of the founders. The association is engaged in activities including holding exhibitions, overseas exchanges and creating botanical illustrations.

In particular, the trilogy of illustrated books pub-lished in 2020—"Nihon No Zetsumetsu Kigu Shokubut-su Zufu" (Illustrated Book of Endangered Plants in Japan), "Nihon No Kika Shokubutsu Zufu" (Illustrated Book of Naturalized Plants in Japan) and "Nihon No Koyū Shokubutsu Zufu" (Illustrated Book of Endemic Plants in Japan)—has received high praise both within Japan and internationally. Please see the website for details, including how to join and how to order copies. The members' artwork featured on the Gallery pages is particularly worth viewing.

"Books to Span the East and West"

Tuttle Publishing was founded in 1832 in the small New England town of Rutland, Vermont (USA). Our core values remain as strong today as they were then—to publish best-in-class books which bring people together one page at a time. In 1948, we established a publishing outpost in Japan—and Tuttle is now a leader in publishing English-language books about the arts, languages and cultures of Asia. The world has become a much smaller place today and Asia's economic and cultural influence has grown. Yet the need for meaningful dialogue and information about this diverse region has never been greater. Over the past seven decades, Tuttle has published thousands of books on subjects ranging from martial arts and paper crafts to language learning and literature—and our talented authors, illustrators, designers and photographers have won many prestigious awards. We welcome you to explore the wealth of information available on Asia at **www.tuttlepublishing.com.**

Published by Tuttle Publishing, an imprint of Periplus Editions (HK) Ltd.

www.tuttlepublishing.com

ISBN 978-0-8048-5639-3

HAJIMETE NO BOTANICAL ART
Copyright © Hidenari Kobayashi 2021
English translation rights arranged with
NIHONBUNGEISHA Co., Ltd.
through Japan UNI Agency, Inc., Tokyo

English translation © 2023 Periplus Editions (HK) Ltd
Translated from Japanese by Wendy Uchimura

Staff (Original Japanese edition)
Cover Design Amane Kiribayashi (amane design)
Text Design / DTP Naoko Kuge
Editor Katsura Yoshimura (NIHONBUNGEISHA)
Editorial Support Kazue Sudō (Viewkikaku Co.Ltd.)
Photography Norihito Amano (NIHONBUNGEISHA)
Publisher Yoshichika Yoshida

Distributed by:

North America, Latin America & Europe
Tuttle Publishing
364 Innovation Drive
North Clarendon
VT 05759-9436 U.S.A.
Tel: (802) 773-8930
Fax: (802) 773-6993
info@tuttlepublishing.com
www.tuttlepublishing.com

Asia Pacific
Berkeley Books Pte. Ltd.
3 Kallang Sector, #04-01
Singapore 349278
Tel: (65) 6741-2178
Fax: (65) 6741-2179
inquiries@periplus.com.sg
www.tuttlepublishing.com

27 26 25 24 23 10 9 8 7 6 5 4 3 2 1
Printed in China 2305EP

TUTTLE PUBLISHING® is the registered trademark of Tuttle Publishing, a division of Periplus Editions (HK) Ltd.